RAIN LATER, GOOD

ILLUSTRATING THE SHIPPING FORECAST

RAIN LATER, GOOD

ILLUSTRATING THE SHIPPING FORECAST

Peter Collyer

ADLARD COLES NAUTICAL
London

Published by Adlard Coles Nautical
an imprint of A & C Black Publishers Ltd
38 Soho Square, London W1D 3HB
www.adlardcoles.com

First edition published by Thomas Reed Publications 1998
Reprinted 1999, 2000
Second edition 2002
Reissued by Adlard Coles Nautical 2005
Reprinted 2006

ISBN 0–7136–7397–4

A CIP catalogue record for this book is available
from the British Library.

A & C Black uses paper produced with elemental chlorine-free
pulp, harvested from managed sustainable forests.

Edited by John Lloyd
Design and page layout by Eric Drewery
Printed and bound in Singapore by Tien Wah Press Pte. Ltd

The Shipping Forecasts are Crown copyright. Extracts and the full
forecast for 30 July 1992 are reproduced with the permission of
the Controller of Her Majesty's Stationery Office.

Registered at Stationer's Hall

Peter Collyer is represented by
Chris Beetles Ltd, St James's, London
Telephone 020 7839 7551
Specialists in English Watercolours

HRH The Duke of Kent, KG

YORK HOUSE
ST. JAMES'S PALACE
LONDON S.W.1

As President of the Royal National Lifeboat Institution, I always find the Shipping Forecast a highly evocative programme. Those short, terse statements about wind strength and visibility immediately conjure up images of streaming waves, gale force winds, impenetrable fog or freezing rain; images that are very much associated with the lifeboat service. Despite being well aware that lifeboats are built and equipped to withstand the most ferocious weather, I, like most people, still experience a shiver of dread and my thoughts go to the lifeboat crews when I hear forecasts of extreme weather conditions. Knowing that those volunteer crews will always launch to go to the aid of those in distress, whatever the weather, makes me continually admire their dedication and self-sacrifice.

This exceptional book, so beautifully illustrated, will support the work of the lifeboats both by highlighting the conditions that they may experience, and in a practical way through financial donations.

HRH The Duke of Kent
President
The Royal National Lifeboat Institution

For Joy and Laurie

I dedicate this work to my heroes, the crews of the RNLI lifeboats.

ACKNOWLEDGEMENTS

I must above all thank my friends Melvyn and Peter Matthews. Without their immense contribution, enthusiasm and support this venture would not have been possible.

I am indebted to my friends and relatives whose advice, encouragement and support kept me going, especially Tom and Becky Glenister.

Three people need to be singled out for their special contributions; John Lloyd, my editor and publicist whose skill, cheek and Cheltenham accent persuaded others to contribute beyond what I would have expected their job security to allow. My cousin John Douce and friend Geoff Wyatt who, in turn, accompanied me on some of the expeditions. Their planning, knowledge, company and driving skills contributed greatly to the success of the journeys and my enjoyment.

Many people and organisations contributed to the success of my travels, especially NERC and the crew of *RRS Discovery*.

I wish to acknowledge also; Doug and Amanda for a Scilly day out, Coopers Garage (Calne) Ltd, P&O Scottish Ferries, Queen's and Kveldsro Hotels in Lerwick, Scotrail, Smyril Line, Icelandair, Henri Lloyd and everyone involved with Newhaven Lifeboat.

During the writing of the text I pestered many people for information, none more so than Nathan Powell at the Met. Office Press Office who is now one of the best friends I have never met.

I am grateful to the following; The crew of HMS Calne Library, BP Exploration, Color Line, Dovre Safetec, Pro Arte, Department of Trade and Industry, Humber Coastguards, Hydrographic Office, Plymouth Marine Laboratory, Isle of Man Meteorological Office, Met Éireann, Meteorological Office, Western Isles Council, Greenpeace, Lloyd's of London, The National Trust for Scotland, North Atlantic Fisheries College, Northern Lighthouse Board, Trinity House Lighthouse Service, the RNLI, Charlotte Green, Colin Ridsdale, Ambrose Greenway, Patrick Rule and Mrs Helen Tew.

Special thanks are due to Chris Beetles and Allan Brunton-Reed for allowing me this indulgence.

Contents

GENERAL INTRODUCTION

What is it about the Shipping Forecast that has enabled it to work its way into our national psyche? That it is needed is clear enough. Its essential and precisely delivered information is a service for those in peril on the sea. For most of us who rarely venture beyond the shoreline it is, in theory, something we can live without, but we seem unable to. For many of us it is a kind of service, an arcane meteorological mantra, reminding us that we are an island community. For both groups it is about security.

For whatever reason, it is there in our hearts and minds, weaving its mysterious spell. Some people name their pets after the sea areas. Some will talk back to it, 'Thundery showers good? I don't think so'. Many of a certain generation break into song at the mention of occasional rain, and follow it with 'chilli carne, sparkling champagne' à la Nat King Cole from *Let there be love*. For many its comfort is in its continuity, a nostalgic link with a more innocent past, Sunday roast followed by peaches and cream, with *Two Way Family Favourites* on the radiogram.

I started listening in the fifties at the age of two or three, in those pre-children's television days, waiting by the wireless just before two o'clock for *Listen with Mother*, 'Are you sitting comfortably? Then I'll begin'. I cannot remember anything of what followed, but Dowsing, Galloper and Ronaldsway lodged themselves somewhere at the back of my mind, where they remained dormant for thirty-five years. In the meantime I had been through school and art college. In the former I developed an interest in, and a rudimentary understanding of

meteorology and geology, and at the latter I learned how to harness an innate ability to draw. The two came together when I later discovered watercolour, for me the perfect medium for expressing my thoughts and experiences of the landscape.

While I sat at my studio desk one day the Shipping Forecast came on the radio. Not an unusual event, BBC Radio 4 is a permanent fixture and I hear the forecast twice most days. For some reason, on this particular day the jump leads had been connected to the dormant Ronaldsway, so when the continuity announcer turned the Shipping Forecast key it burst into life. The idea immediately ran like a well maintained straight-six engine, carrying me off on a 16,000 mile odyssey.

Once the idea was running it seemed such an obvious thing to do, I could not understand why it had not been done before. Perhaps there are not many Radio 4 listening, coastline painting watercolourists with an interest in travel and a basic understanding of meteorology.

I soon learned that being inspired by the Shipping Forecast was not unique. Three of our most notable living poets, Seamus Heaney (Glanmore Sonnets – VII), Sean Street (Shipping Forecast Donegal) and Carol Ann Duffy (Prayer) have been moved by what Sean Street refers to as 'the cold poetry of information'. Some see the forecast itself as 'found poetry'. Charlotte Green, the Radio 4 continuity announcer I find the most inspiring reader of the Shipping Forecast, has said that it is the nearest she gets to reading poetry on air.

Musicians have turned to the forecasts for inspiration. It pops up occasionally, sometimes as a knowing

reference in a lyric, as in *Clover over Dover* on the successful Parklife album by Blur, or just 'as broadcast', as the vocal track to which a piece of music has been added. On *General Synopsis* by The Rootsman, the Radio 4 reading is backed by rythmic electronic music with an Islamic feel to it, perhaps an invitation to get on our prayer mats and face Broadcasting House.

I know, too, of another visual artist who has been inspired by the broadcast. Ros Pritchard produces 'things handwritten', something beyond calligraphy. Some collage pieces and silk hangings called *Sea Litany* have the names of sea areas written in a way that suggest the motion of the waves.

I have never thought of the Shipping Forecast as a litany. That suggests to me a fixed response to every name. Its fascination for me lies partly in the ever changing information being broadcast. We tend to think that the broadcasts themselves are reliably unchanging but this is not so. I heard Ronald Fletcher in an archive recording from 1950 and was surprised at how different it was, not least the reverse order of the sea areas: 'Shannon, Irish Sea, Fastnet, Lundy, Sole. Fresh or strong south to south-west winds, occasional rain or drizzle, visibility becoming moderate or poor with some fog patches. Plymouth, Portland, Wight, Dover, Thames, Humber, Heligoland, Dogger...'

Covering the 3,500 km from Eskifjordur in Iceland to Larache in Morocco, and the 1,400 km between Rockall and the mouth of the River Elbe, the Shipping Forecast informs and determines the movements of those afloat. Whether they be in one of Britain's one million pleasure craft, 10,000 fishing vessels, or one of the 400 cargo ships arriving daily at British ports, it is the essential factor guiding their safety and comfort.

It has not been a constant unchanging event. Since its inception there have been many modifications. Sea areas have been divided to allow for more accurate forecasts as technology has improved. The most frequent changes occur to the coastal stations, caused most recently by the demanning of light vessels and lighthouses. Indeed, this second edition of the book has had to incorporate a change to the name of sea area Finisterre. In February, 2002, following extensive international discussions, it became FitzRoy. At least Britain has been able to claim a small victory in naming the area after one of its own.

Although the information given is just as speculative as for any other weather forecast, its format and language sets it apart, giving it its magical quality. Qualifying words like wind, weather and visibility, which would otherwise be repeated many times are omitted, leaving their data as isolated words which then become juxtaposed with other similarly detached words forming new phrases with puzzling meanings. Words and phrases used as vague terms in everyday speech suddenly become precise limiters of information, rising, now rising, moderate, steadily, rather quickly.

The BBC Radio 4 broadcast is unique but not as essential as it used to be. Many of those who need to know now receive the information by other means. For instance most ships of any consequence are now fitted with NAVTEX which prints the forecast automatically. The RNLI lifeboat stations, indeed anyone, can have it faxed direct from the Met. Office or find it on the website.

So do the advances which have helped those who cannot leave port without it mean its eventual loss for those who cannot stay at home without it? According to the Met. Office, when the BBC merely moved the late night broadcast back by 15 minutes 'People went ballistic.'

The Shipping Forecast puts us in touch with a world which for many is a mystery. A daily tour of our surrounding seas, evocative names, enigmatic inform-ation, it has its own cadence delivered with a gentle gravity, precise yet poetic. Where else could something as mesmeric as '4 occasionally 5 in Forth at first' be the difference between life and death for some, and for others the inspiration for poetry, prose and song, and an essential companion on *Desert Island Discs*?

SEA AREAS
INTRODUCTION

When broadcasts began in 1911 they were in Morse code and took the form of gale warnings for the western approaches. In 1921 this became a twice daily weather message.

The first sea area map appeared when the forecasts were extended to cover the seas all round Britain in 1924. The seas were divided into three large areas; Eastern, Southern and Western, each of which was sub-divided into districts which related more closely to some of the current sea areas. Tay covered what is now Cromarty and Forth, Severn was present-day Lundy and Fastnet, Malin and Irish Sea were Clyde and Mersey, and Portland, Plymouth and Sole were Channel.

In October 1925 the BBC translated the Morse code broadcasts into spoken English and the first transmissions of something resembling the present day Shipping Forecast began to come out of our wireless sets at home.

In 1932 a Northern area was added to the map consisting of three districts; Orkney, Shetland and Faeroes. At this time virtually the whole of the North Sea was just Forties and Dogger.

Broadcasts were suspended for the duration of the Second World War. In 1949, when shipping had returned to normal, the map was given a new format, omitting the four large regional areas and extending further to the west in more detail. This map has survived to the present day with a few modifications, notably the addition of North and South Utsire in 1984 and the change of name from Finisterre to FitzRoy in 2002.

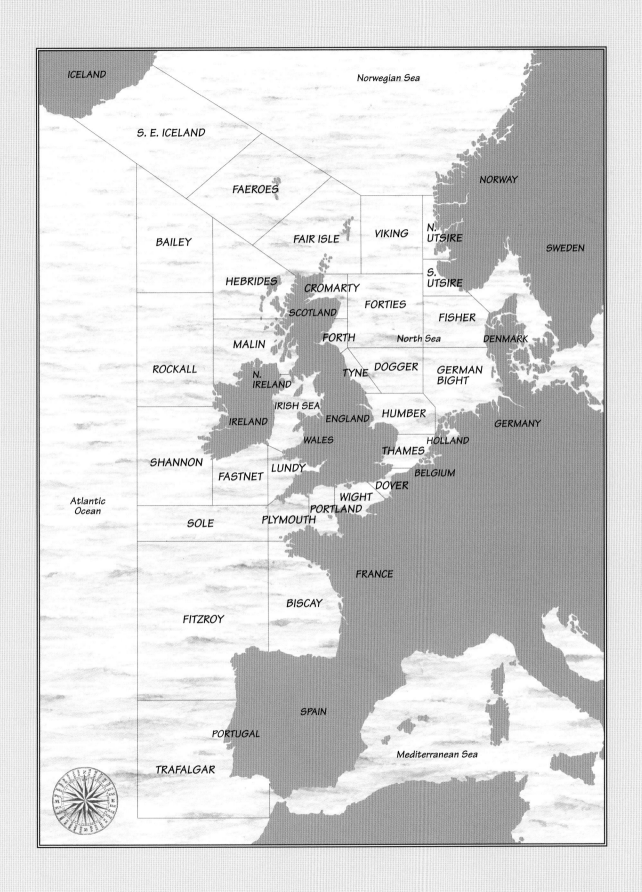

VIKING

King Canute is best re-membered for sitting on the shore and failing to stop the in-coming tide. In any struggle between man and the sea it tends, as then, to be the sea which wins. We do our best, however; tune to BBC Radio 4 at 05.35, 12.01, 17.54 or 00.48 hours and you will find the Shipping Forecast. Daily it pro-vides information to enable us to challenge the sea as we go about our work or travels.

It begins its mesmerising tour of the sea areas and coastal stations around our shores with Viking. How appropriate that it should start with the name of a culture, the power of which came from prowess at sea. Almost a thousand years after Canute II united the crowns of England, Norway and Denmark in a North Sea empire, the Viking influence is still part of our everyday lives.

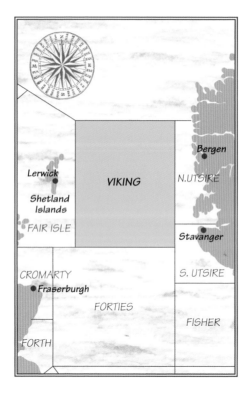

Viking has not always been part of the Shipping Forecast. When broadcasts began in 1911 they took the form of gale warnings for ships in the western approaches only. It first entered the list as a separate area in 1956. Many changes took place over the years until the present area called Viking was outlined in order to give a more detailed forecast for the increased shipping off Norway created by the oil and gas industry. The eastern parts of Viking and Forties were redrawn in 1984 adding North and South Utsire.

My journey through the Shipping Forecast has been a bit like this, criss-crossing the seas, redrawing lines and working to offer something definitive and useful about the places.

Take the P & O ferry from Aberdeen to Lerwick during the summer months, and you can link up

Viking
Southerly 3 or 4.
Occasional drizzle.
Moderate with fog patches.

with the Smyril Line ferry which plies the North Atlantic between Bergen, Shetland, the Faeroes and Iceland; the Viking trail. I came the way of the Vikings and travelled from Bergen where I had visited the museums in search of those first millennium forbears.

Looking out from the deck of the ferry as we sailed into sea area Viking, with sea area Tampen of the Norwegian Sea somewhere over the horizon to the north and the North Sea to the south, I imagined that it could have been just the same scene a thousand years ago: The unchanging sea and sky with an invasion fleet of longships off to the Hebrides, or Leifur Eriksson on his long voyage to find Vinland.

The illusion was brief. Into view came the twentieth century, in a form as dramatic and symbolic as it could possibly be: Oil rigs; monstrous, awesome. I knew we would encounter them, but was staggered by the number out there. Quite simply, I had not imagined what a stunning sight they would be. Surprisingly, my artistic eye was not offended. Yes, they had a sinister look, but as buildings they were impressive. And what a location!

It seems to me the Vikings have suffered from just as bad a press. It is fair to say they were not angelic, I guess they did not write home to mother every week with news of their exploits, or while away the dark winter months crocheting. There must be some truth in the early accounts of their arrival, but these were written by Northumbrian

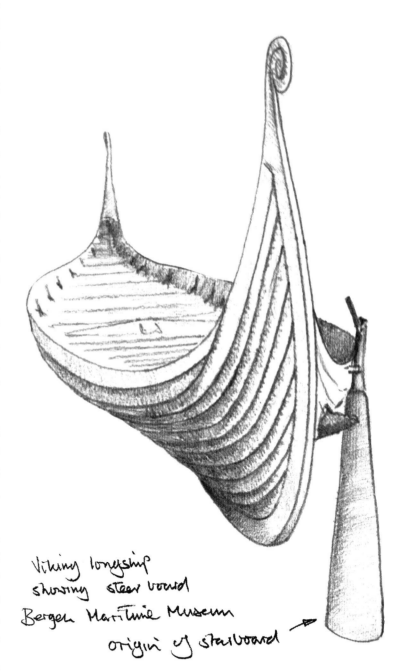

Viking longship
showing steer board
Bergen Maritime Museum
origin of starboard →

monks who may have had a slightly jaundiced view of their behaviour.

Viking: 'Southerly 3 or 4. Occasional drizzle. Moderate with fog patches,' said the Shipping Forecast. For much of the journey it was nothing like that. I was experiencing good visibility and thankfully there was no drizzle. So, like the monks of old, should I give only my version? Doubtless the forecasters knew their business. I had my own business to attend to, that of recording the scene in sketches and a painting.

What would I leave for posterity from Viking?

Those who gave this sea area their name may not have created an enduring civilisation, there were no grand buildings or many great works of literature, probably because they had no need for them. But they left beautiful art and craft work and a great spirit of adventure.

These were, perhaps, all distilled into the one object that symbolised their achievements; the magnificent Viking longship. Here were seagoing vessels of great power and mobility.

The Vikings travelled great distances trading with established cultures across Europe, discovering and settling in previously uninhabited lands across the North Atlantic, the Faeroe Islands, Iceland and Greenland and eventually even establishing a settlement in Newfoundland on the north American continent.

The most significant aspect of Viking culture was their ability to assimilate into the societies they conquered, making tangible evidence of their existence hard to find. Improved forms of trade, farming, administration and justice have been their most enduring legacy, together with a language which still litters ours, even in the Shipping Forecast names for instance; Lundy and Ronaldsway.

In the Bergen Maritime Museum I learned of the Viking origin of a term from our nautical language. Longships were steered by a man standing at the stern, operating a paddle-like device which pivoted on the outside of the hull. This device was always attached to the right side of the hull and was known as the steerboard, hence starboard. Again and again during my journeys around the Shipping Forecast I was to pick up such interesting snippets of information.

NORTH UTSIRE

Haugesund in Norway is an ordinary workaday sort of town set in a green but rocky landscape, pleasant but unremarkable. Built, so the legend says, on a bed of herring bones it is still home to a large herring fleet. Now it is reaping the benefit of its proximity to the Norwegian North Sea oil and gas fields.

To call it unremarkable is, on reflection, a little unfair. A former resident emigrated to America and a statue on the quayside commemorates the thirtieth anniversary of the death of his daughter, Marilyn Monroe. Such sunny exotica in the bleak northern surroundings suggests that all is possible; from Hollywood to Haugesund is not so far.

The roads leading into the town are lined with neat detached wooden villas, mostly painted red, white, or red and white, many flying the national

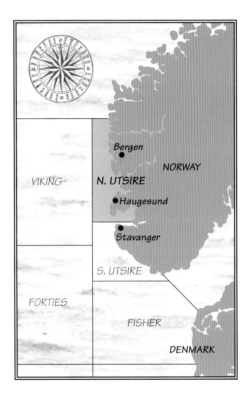

flag. On a warm and sunny Sunday morning in July children played in the gardens, people were hanging washing out to dry, gardening, and answering the call of the church bells which rang out clearly across the town.

It all seemed very natural, apart from the fact that I witnessed this at remarkably close quarters, a stone's throw from the deck of a 20,000 ton car ferry. As it carefully picked its way through the narrow channels which separate the myriad offshore islands and skerries it dwarfed everything around like a vast, white office block.

South west of Haugesund, and further offshore than any other, is the small isolated island of Utsira, which gives its name to the two sea areas that meet a little to the south along the 59° N parallel. The whole of the North Utsire coastline is

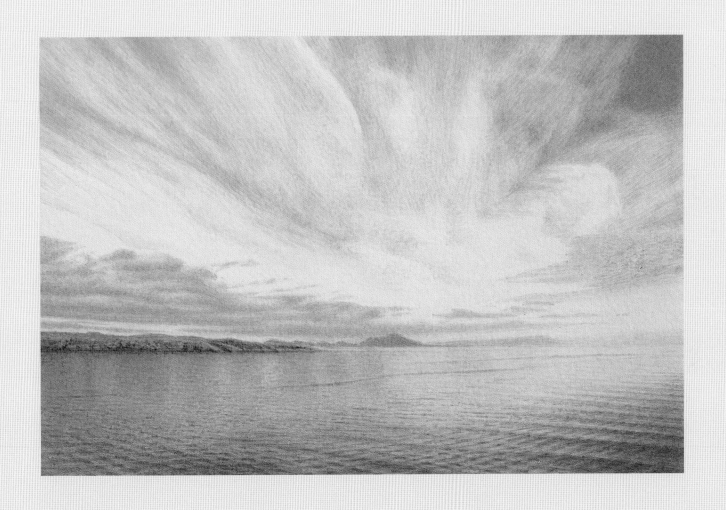

North Utsire
Westerly or southwesterly 3 or 4, increasing 5 in north later.
Rain later.
Good becoming moderate , occasionally poor.

characterised by these islands which are the visible manifestation of a rock shelf, the strandflate, lying just below sea level.

In good weather there is nothing better than sitting on the deck of the Newcastle to Bergen ferry watching these rocky outcrops with their isolated communities drift by. The only negative aspect of this journey is that it keeps at a distance the most wonderful feature of this coastline, the one aspect of landscape which springs into every-one's minds at the mention of Norway, the fjords.

These great glacial gashes gouged out of the landscape can rise shear out of the water a breathtaking 1,000 m. The water itself can be up to 1,250 m deep, ten times that of the surrounding North Sea. Around Bergen and to the north the mainland can be enjoyed at closer quarters. The northern boundary of the sea area ends near the mouth of one of the most spectacular fjords, Sognefjord, the longest and deepest of them all, stretching inland 180 km.

Although many of the journeys along this coast are undertaken on the water, it is sur-prisingly easy to enjoy this area by road. I can offer no recorded statistics, but a comparison between European countries based on the number of major bridges in relation to vehicle numbers would, I am sure, have Norway out in front by a long way. Whichever way one chooses to travel, all routes seem to lead eventually to Bergen.

Sited on a peninsula and surrounded by mountains and fjords which cut it off from its

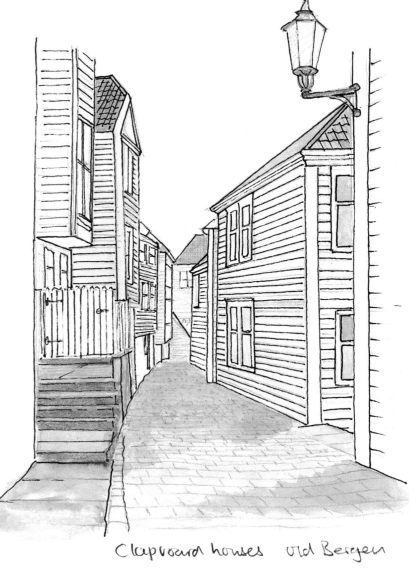

Clapboard houses old Bergen

hinterland, Bergen is dependant on the sea. The most important historical factor in its development, still in evidence today, was its position as one of the four major overseas trading ports for the Hanseatic League with strong links to ports on the east coasts of Scotland and England.

The steeply gabled timber built offices of the Hanseatic merchants still line the east side of the harbour. Sea trade is still the major influence and the bustling open air fish market on the quayside right at the heart of the city is a constant reminder of its nautical roots.

Bergen is a most enjoyable city, easy going, picturesque, cultured, and thankfully, after more than a day aboard a ferry and in need of some exercise, manageable on foot.

The setting is spectacular. From almost any-where in the centre one can look up between the large modern blocks and glimpse the suburbs clambering over the wooded hillsides. The hillsides can be hard work but most rewarding. Immed-iately to the east of the harbour is the old town, a series of steep cobbled streets and alleyways lined with pretty clapboard houses that zigzag their way into the sky. It is easy to get lost, but who cares? It is peaceful and the views are great.

Inevitably, there has to be a down side: Bergen's Achilles heel is what has brought me here, the weather. There is a local joke which is not terribly funny but very effective at making the point.

As it has been raining ever since she arrived in Bergen, a tourist stops a young boy in the street and asks if it ever stops raining here. 'I don't know,' he replies, 'I'm only thirteen.'

Apparently it rains here 290 days a year. This point is reinforced at my pension where I am offered a brolly from a selection better than most brolly shops can muster, 'just in case.'

Usually, when somewhere new I like to wander the streets hoping to find the real place, taking in the atmosphere, simply enjoying being somewhere different; a little puzzled by those who want to spend their time looking round the Municipal Art Gallery. Eventually, however, the inevitable happened. Not that wishy washy drizzle we get at home, but stair rods and spray that makes your feet disappear. So on this occasion I made an exception.

The collection of work by the Norwegian Edvard Munch is extensive, but minus his most famous piece, *The Scream* – the one where the woman is clasping her hands to her head as she remembers she has left home without her false teeth in. Still looking for shelter I visited the Maritime Museum, the Fisheries Museum, the Hanseatic Museum, even the Leprosy Museum. And still outside, with the biggest collection of them all, was the strangely unpublicised Open Air Rain Museum.

SOUTH UTSIRE

Høg Holm is a dapper little man in his *Color Line* uniform, and it was very kind of him to give up more of his time than either of us imagined would be necessary. Just one question;

'Will we be sailing close to Utsire?'

'Utsire?'

'Utsire,' I repeated in my best BBC Peter Donaldson voice. '*Ut sear rer.*'

'Utsire,' he murmured as he shook his head and shrugged his shoulders. 'What is Utsire?'

Oh dear, I thought, if we carry on like this we'll be over the horizon before I'm understood, and by then it won't matter anyway. I showed him my Met. Office map of the sea areas and pointed to the boundary between North and South Utsire. 'Isn't there an island here called Utsire?'

'Ah! Utsira. *Oot* sirra.' The accent was on the

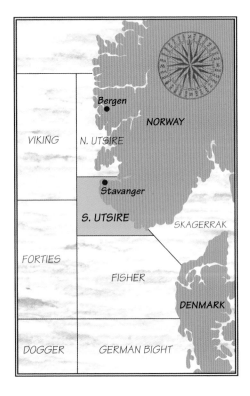

first syllable and the vowel sounds very short.

'Utsira.'

'Utsira. Rrrrrrrrr.' He rolled his rs. 'Utsirrrrra.'

'Utsirrrrra.' I repeated.

'Very good.'

'Brilliant.'

Having established the correct pronunciation I returned to the question.

'So, do we sail close to Utsire, will I be able to see it?'

'No and no, sorry.'

The sea area covers the south-west corner of Norway from Utsirrrrre, a little to the north-west of Stavanger, to its southernmost tip at Lindesnes (meaning 'where the land curves round'). On the promontory at Lindesnes stands Norway's oldest lighthouse, coal fired, next to a modern red and white tower.

During the warm summer months the south coast is *the* place to go, if you are Norwegian. The

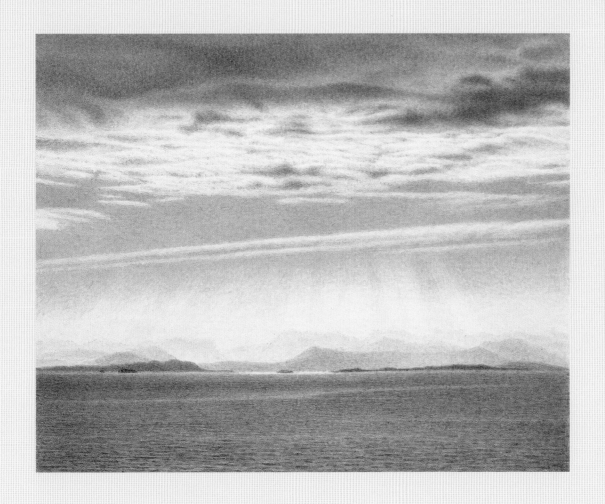

South Utsire
Northwesterly 3 or 4, occasionally 5 later.
Showers.
Moderate or good.

rocky headlands and sheltered coves, backed by a broad, flat coastal plain are reminiscent of southern England. This is more boating than bucket and spade country. Dotted along the coast are a number of small ports which still rely heavily on the local fishing industry. It is all very pleasant, but as a competitor in the Norway Scenery Stakes is an unfortunate also ran. Around Stavanger however the landscape is far more interesting as the fjords and mountains begin here.

Stavanger shelters on the leeward side of a narrow promontory, on the south side of the broad estuary of Boknafjord, which has the islands of the Ryfylke archipelago scattered across its entrance.

Approaching from the west the city was hidden from view, the scene was of a low rocky coastline with a scattering of islands and skerries bathed in bright early morning sunshine.

Standing at the handrail of the ship, I met up with a Scot from one of the oil rigs who had built himself a log cabin retreat in the mountains. Mountains? I could see none. He pointed and made me look more closely. I peered into the brilliant sunshine. Sure enough, barely visible in the dazzling light, there they were, faint silhouettes shimmering in the intense brightness as the warming sun burned off the early morning mist which had kept them hidden.

The setting is not as dramatic or as picturesque as Bergen, and the city is less than half the size, but Stavanger is extraordinary. It is hilly, but modestly so and, like Bergen, the harbour goes right into the centre, there at the heart of everything that happens. It is something of a survivor, with riches from the sea twice creating booming prosperity, resulting in two distinct aspects to the place.

First it was herrings and brisling. In the nineteenth century catches were huge, and the fishing fleets multiplied dramatically. Originally the fish were dry salted but then along came the can and, although the local herrings had all but disappeared by around 1870, the city became the sardine capital of the world, with more than 50 canning factories when the trade was at its peak. Of course, the inventor of the sardine can key had to come from Stavanger, and this was such a significant technological step forward that it became the city's symbol.

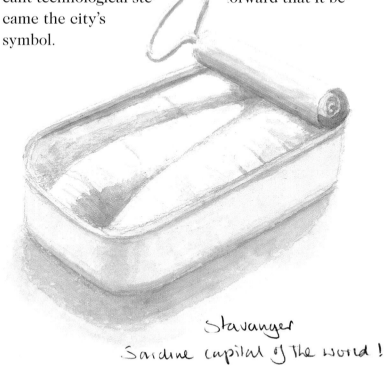

Stavanger
Sardine capital of the world!

I, too, was looking for a key to this sea area of South Utsire. Those distant mountains viewed from the water seemed to offer the very essence of the place.

Scandinavian breakfasts were also memorable. Dark, sweet rye bread with creamy cheeses and ham were an especial delight. I was tempted to begin a new study; breakfasts around the Shipping Forecast. Already I had begun to compare the delightful and diabolical offerings of fish and chips on my travels.

Adjacent to the quay where the ferry from Newcastle ties up is Gamle Stavanger, the old part of the city which housed the families of the fishermen and sardine cannery workers. It is still a residential area with narrow cobbled streets of white painted clapboard houses and pretty gardens, retaining much of the flavour, but thankfully not the smell, of the nineteenth century. With more than 150 houses it is thought to be Europe's best preserved collection of wooden houses.

Here, on Øvre Strangate is the unlikely but fascinating Hermetikkmuséet, the Canning Museum. Set in an old canning factory, where canning and smoking is still done. Sadly it is the only place in town where the traditions are carried on. Fortunately the industry continued long enough to protect Stavanger from serious decline until the 1960s when the second boom came along in the shape of North Sea oil.

Stavanger is now the oil capital of Norway, directing and coordinating the country's oil production programme. Rig and platform construction, oil refining and shipbuilding may not be the most attractive or glamorous of trades but it has made the city prosperous, vibrant and surprisingly cosmopolitan, with a modern steel and glass skyline to match.

It is the city that has put the hip into shipping.

FORTIES

The only way to get to see the sea area Forties is by boat. Like Viking it has no coastline. I sailed through on the car ferry *Color Viking* which was originally built to cross the Baltic where ice breaking is an essential feature. We moved along at 22 knots – the speed the ill-fated *Titanic* was travelling when she met her end. My summer crossing on a flat North Sea was somewhat less dramatic.

One way of relieving a monotonous sea voyage is to ask for a visit to the bridge; easy if the crew speak the same language, but not so easy if you are a mad painter engaged in illustrating the Shipping Forecast.

The romance of the Shipping Forecast can prove a little difficult to convey to someone who has never heard it read by Charlotte Green or Brian Perkins, especially if their English is

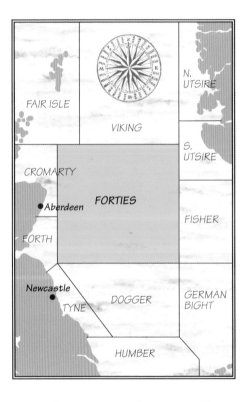

somewhat sketchy. However, a mention of the BBC together with the wave of a reporter's note book did the trick.

If you have ever wondered what goes on up there on the bridge, the surprising and disturbing answer is not a lot. On this occasion the ship appeared to be sailing itself. With only one officer on duty monitoring all the equipment, it made the bridge of Star Trek's *Enterprise* looked manned at Victorian levels.

Close accuracy abounds in all things. The Global Positioning System which uses data from satellites to compute the ship's position is accurate to within five metres. This enables precise arrival times to be calculated. Looking for a feature for my painting, I asked about the flares I could see on the horizon. The ship's officer, consulting the GPS, told me that we would be

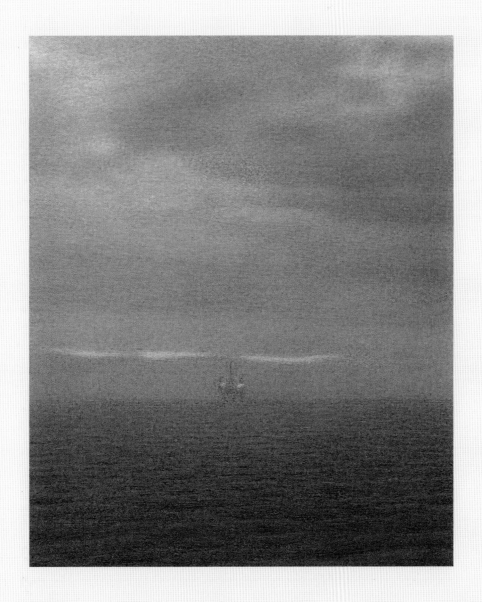

Forties
Westerly backing southwesterly 3 or 4.
Rain at times.
Good.

passing very close to the rig *Machar* at 11 pm. Conditions were calm and the weather dull, but even mid evening it was clear that it might still be light enough for me to capture this in my sketch book as we passed.

The Forties Field, 170 km off Aberdeen was Britain's first major oil find in the North Sea. The oil was in an area where the sea was more than 120 m deep. Wave heights could be 28 m and wind speeds up to 200 kph, so despite my calm progress through the area, this oil was never going to be easy to obtain.

Sea area Forties should not be confused with the Roaring Forties. These are winds in the southern hemisphere. Our Forties is so called because the greater part of its waters are forty fathoms, that is about 75 m, or more deep. The average depth of the North Sea as a whole is a mere 55 m, although it is more than 660 m at its deepest point – still shallow when compared to the four to five kilometres of most of the world's oceans.

All of this information came from study in my local library before I travelled. Miss Boddington, the librarian, is used to my strange requests. There's plenty of time to think when one is painting in the studio and I seem to have that sort of mind which wants to know odd details. I learned a lot from books with titles like *The Adventure of North Sea Oil* and *Weird Weather*. I have become an expert in all sorts of subjects; a Jack of all trades – full of apparently useless information. That, for instance; sailors were known as jacks,

and, unlike the soldier who tended to specialise, they did everything on board ship. Throughout my travels around the Shipping Forecast I constantly became aware of just how many of our common phrases are connected to the sea.

Standing on the bridge of the ship surrounded by water I found it surprisingly easy to understand how it had been possible for geologists to guess at what might be the make up of the North Sea area by studying the geology of the surrounding countries.

It seems that the existence of carboniferous rock on land, the coalfields of Britain, Holland and Germany led to the deduction that a carboniferous deposit extended across the southern North Sea basin. Oil is only found in sedimentary layers like this, being formed by decaying marine life in areas of shallow water.

Oil had been found in these three countries in the 1950s, but yields were small making production uneconomic in the difficult conditions of the North Sea. Geologically, the area was not highly rated.

That was until 1959, when a huge gas field, the second largest in the world, was discovered by a rig drilling in a sugar beet field in the Dutch province of Groningen. Chemical analysis showed the gas to be carboniferous in origin, suddenly the North Sea became one of the best prospects in the world.

By the end of 1965 gas was being found in commercial quantities all over the southern North

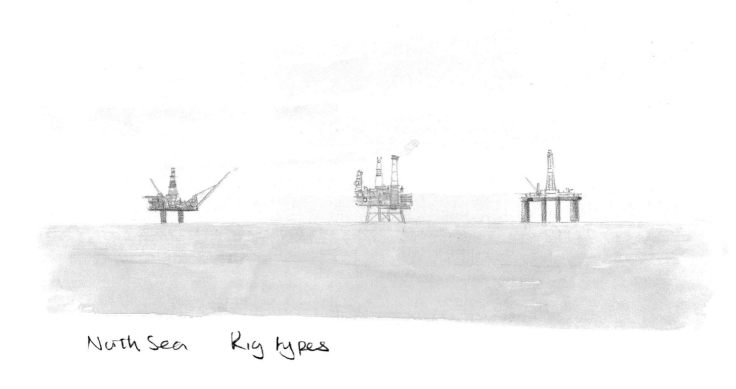

North Sea Rig types

Sea. The first minor oil strike did not come until 1966 – off Denmark in a layer of Danian chalk of the same geological age as the white cliffs at Dover. Two years later the same chalk formation produced the first commercial find of North Sea oil; the giant Ekofisk field.

Original estimates for the Forties field were that there would be enough oil to produce twenty per cent of Britain's oil needs at that time.

Improvements in drilling technology have allowed greater volumes to be tapped and the field is still going strong. There are now 27,000 people working in this industry in the North Sea.

It was difficult to grasp all of this when out at sea. One can see so little over the horizons. Anyway, almost as predicted, we passed *Machar* at 10.55pm. It was still visible in the dim light of dusk and I was able to make my preliminary drawings.

CROMARTY

Travel north-east along the Great Glen by the shores of Loch Ness and when you reach Inverness the Glen becomes the Moray Firth, the local branch line of the North Sea.

From Inverness the south side of the Glen sweeps away to the east and changes into a low lying coast of sandy bays stretching for 50 km until it reaches the rocky headland of Burghead. The north side of the Great Glen however is very different. It continues straight on for more than fifty more kilometres as a great red sandstone ridge diminishing in stature as it progresses north. It ends at the Tarbat Ness lighthouse.

Mid way along this ridge there is a break at which point the Cromarty Firth enters the Moray Firth. The matching pair of cliffs created by this meeting of waters are known as the North Sutors and the Sutors of Cromarty. Between the two Firths is a low lying peninsula, the Black Isle – so called because in winter a relatively mild climate leaves the soil dark and bare when the hills around are white with snow. At the north-east tip of the Black Isle, with water on two sides and sheltering in the lee of the Sutors, is the splendid little town of Cromarty.

The sea area of this name takes in the coast from Wick in the north to Stonehaven to the south and includes Scotland's third city Aberdeen (now the major mainland base for the North Sea oil and gas industry) and the two important fishing ports of Peterhead and Fraserburgh.

The Moray Firth takes a considerable bite out of this coast so it is surprising that the sea area is not called Moray rather than Cromarty. During my

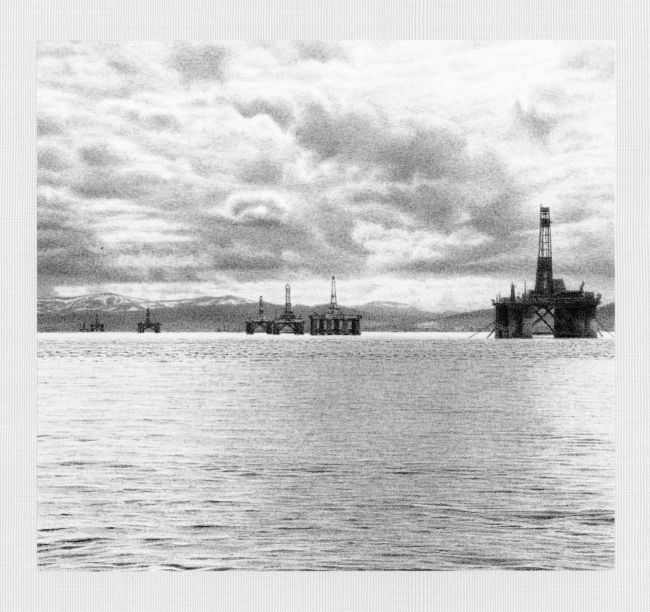

Cromarty
Northerly backing westerly 3 or 4, increasing 6 later.
Showers.
Good.

journeys around the Shipping Forecast I, like so many before me, I suspect, often fell to musing why certain of the names might have been chosen. Here I speculated that the reason could well have lain in the sound of the name.

Imagine yourself to be a Fraserburgh trawlerman. It is 1949, when this sea area was first introduced, and you are battling home against a force 10 gale. Mountainous waves are crashing over your decks which are awash with sea and cod.

The diesel engine throbs. In the wheelhouse the radio is tuned to a fading BBC Home Service signal. You are trying to take down the Shipping Forecast which is being read from London by someone with a plummy English accent and wearing a dinner jacket (in those days, they really did!): 'Forties, Moray, Forth...' would sound pretty much alike, but 'Forties, Cromarty, Forth ...' is much clearer.

It was just a thought; one of so many odd ideas which afflict a travelling painter.

This is the second town of Cromarty. The first was swept away by the sea. The quality of the buildings suggest that two hundred years ago Cromarty was a more significant place than it is now. An attractive compact town, the narrowness of the old streets and the relatively modest nature of the development along the waterfront give an air of a village by the sea. From the waterfront are good views across and down the Cromarty Firth, one of the largest natural harbours in Europe, used by the Royal Navy in both world wars.

I arrived in the town late afternoon on Whit Sunday after a two day drive from home. I

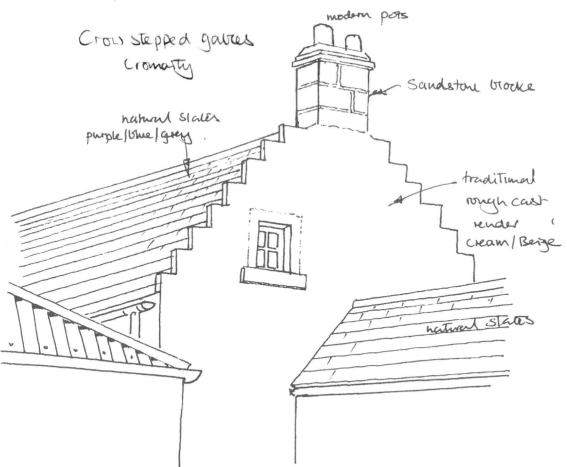

Crow stepped gables Cromarty

modern pots

Sandstone blocks

natural slates purple/blue/grey.

traditional rough cast render cream/Beige

natural slates

drove up to the Sutors, a steep climb on a narrow track which was well worth the effort. From the top there is a superb view looking down on the town and along the Firth. The backdrop of Ben Wyvis and the mountains of Easter Ross away to the north-west were streaked with sparkling white snow.

In Cromarty, having parked near the small sheltered harbour, I wandered along the water-front where there is an open grassy area with a small lighthouse and coastguard station. The slipway is the landing point for a small ferry which shuttles back and forth across the Firth to Nigg Ferry.

Most noticeable were a number of houses which had crow-stepped gables. This not uncommon feature along the north-east coast suggests past trading links with the Low Countries. Quite what the worthy burghers of the flat lands of Flanders made of this magnificent mountainous view which I enjoyed from the waterfront is hard to imagine. Looking for a scene for my painting, I knew that these wonderful mountains would have to make an appearance.

It was a cool bright evening with a breeze rippling the Firth. Looking out to sea between the Sutors the sky was clear and blue but over the land there were clouds. Down the Firth the mountains stood out as a blue grey silhouette, with their tops streaked with snow. Standing at the water's edge, with just the clouds, mountains and Firth in view I was aware of a harmony of colour; everything had taken on a bright steely hue. No doubt this was a scene repeated at several other places that evening, but there was one additional element which transformed it into something quite unique.

Down the centre of the Firth, starting on the leeward side of the Sutors and stretching inland as far as one could see was a line of eight oil rigs. Their massive size dwarfed everything else man-made – only the mountains could compete. They were a surreal sight, but I did not find their presence offensive. Quite simply, they looked majestic.

Construction work was under way on the rig nearest the town. The sound of drilling and hammering, with the occasional alarm bell, rang out across the water shattering an otherwise tranquil evening. There was a strange contradiction in this scene. The overall impression was that the natural elements had taken on a muted metallic colouring. It was the oil rigs which offered the only splash of strong natural colour, a brick red.

FORTH

Where would I be without the Ordnance Survey Landranger maps? They have constantly proved a good starting point for finding my way around an unfamiliar area. The amount of detail, particularly the minor roads, footpaths and contour lines are perfect for identifying suitable subjects and viewpoints for pictures. Armed with maps 59, 66 and 67 I travelled in search of a good view of the Forth estuary.

In the top left corner of map 67, *Duns Dunbar & Eyemouth*, at about 2.5 km offshore is Bass Rock, which I had identified as a possible subject for the painting in this sea area of Forth. The rock is a volcanic plug projecting 115 m out of the sea – all that remains of an eruption after the cone of ash has eroded away. This particular example is only one of several that are a feature of the landscape around the Firth of Forth. Close by is another, the impressive North Berwick Law which at nearly twice the height is visible from almost anywhere along the Firth. Probably the most famous of these volcanic outcrops is Arthur's Seat in Edinburgh.

Overlooking the shore, next to the village of Auldhame, the map indicates the ruin of Tantallon Castle and a lane off the main road leading through a wood to a beach between two rocky outcrops with unusual names, The Gegan and St. Baldred's Boat. I have found through experience that many castle sites marked on maps in reality amount to very little. Not so Tantallon, which is a very impressive ruin.

The russet pink sandstone walls were a striking sight as I aproached from the south. Off a little to the right in the middle distance was Bass Rock

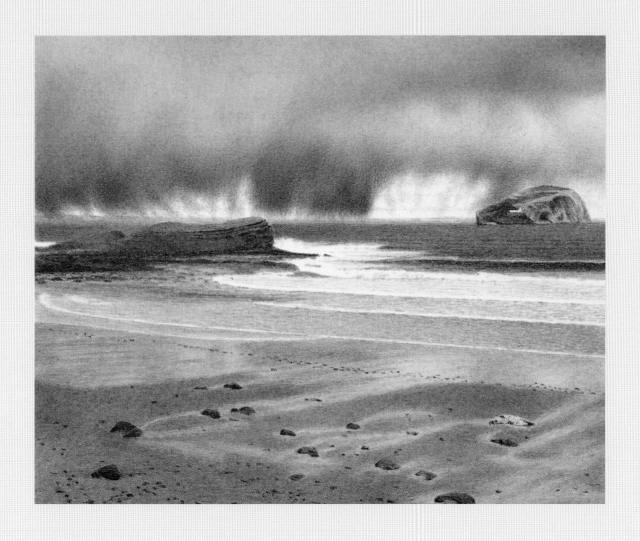

Forth
Northwesterly 6, backing southwesterly 4 or 5.
Showers, wintry at times.
Mainly good.

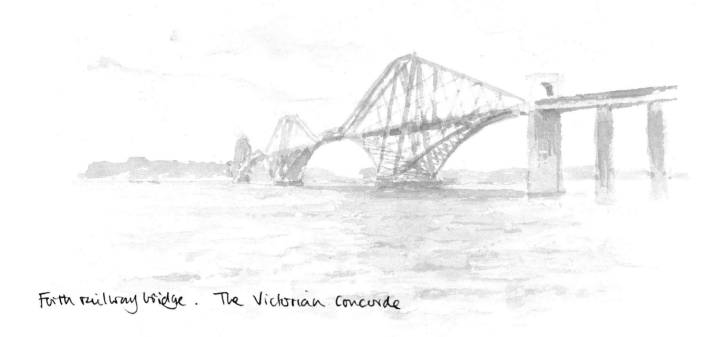

Forth railway bridge. The Victorian Concorde

with its mainland facing lighthouse, and, just discernible near the horizon and about to disappear in a shower, was the Isle of May sitting astride the entrance to the Firth. I was sure that Bass Rock would be a good subject but was not so convinced about Tantallon. A little too picturesque, I felt that a painting of this scene could look contrived.

I continued down the lane to the beach where a more natural scene greeted me. A heavy shower, possibly sleet or hail, was passing across the Firth. Through it could be seen a sunlit north shore where the Firth of Forth meets the North Sea at Fife Ness.

The eastern half of the southern shore is an area of low lying countryside with broad sandy bays and miles of links golf courses, the most famous being Muirfield. Golf and Scotland seem to go together like the sea and the sky. Not so another sporting fixture I encountered in this area.

As one approaches Edinburgh the rural gives way to the urban and the coastline disappears behind two hundred years of development. In Musselburgh I came across one of the strangest urban sights I have seen anywhere. Running alongside the busy main road with just a fence to separate them is a racecourse. Horses racing cars; would the traffic not disturb the horses, or the horses the traffic?

By the time the countryside establishes itself again to the west of Edinburgh the two shores are much closer. At Queensferry there is a considerable narrowing of the water and at this point

the river and firth – an old Norse word, related to fjord, meaning estuary – meet. As the name Queensferry suggests, this was the point nearest to Edinburgh at which the Forth could safely be crossed by ferry.

The ferry has not operated since 1964 when its function was replaced by the Forth road bridge. Light and graceful, but because of our familiarity with such designs, like those across the Severn and Humber, it is very much taken for granted. The great disadvantage for this road bridge is having to live with its much more celebrated neighbour, an icon of Victorian engineering, dwarfing the two Queensferrys for more than a century, the Forth railway bridge.

When design work began, the beautiful Clifton suspension across the Avon gorge in Bristol was already twenty five years old, but the technique was still considered to be somewhat experimental. With the disastrous collapse of the Tay bridge further along the line still fresh in people's minds no one was prepared to take any risks. The designers stuck to sound mathematical principles and the result, like Concorde, is a triumph of 'form follows function'. Brilliant engineering becomes high art.

On the viewing platform at North Queensferry I discovered the cantilever principle, which I found a little hard to grasp, simply demonstrated using a couple of dining chairs. High art showed brilliant engineering.

On the north side of the Firth of Forth is the Kingdom of Fife. Like the southern shore, the western half of the north shore has a more urban than rural feel to it, but the quiet corners that hint of its pre-industrialised past are easier to find. Some, like Kinghorn, have survived relatively unscathed. Dysart, however, has been wonderfully rescued by Kircaldy Council from obliteration and carefully restored to recapture its original character.

East from Largo the rocky coast is broken by a series of small sandy bays. At each one is an attractive fishing village of crow-stepped gables clustered round a small harbour. The most easterly of these villages, Crail, is the prettiest. The local delicacy of Crail crab is simply boiled for 15 minutes, then dropped into cold water to stop the cooking process. It is eaten by extracting the best bits using a hammer and pliers.

At Anstruther, pronounced Anster, is the excellent Scottish Fisheries Museum, full of boats – not as common as you might expect in a maritime museum.

TYNE

As my interest in different subjects changes I become more aware of other artists who have tackled them in the past.

I have known of the American painter Winslow Homer (1836–1910) since art college days, when I saw an exhibition of his drawings at the V & A. He is one of the great painters of the American scene. I do not care for much of his work, done mostly in the Adirondacks, the Bahamas and the Atlantic coast of Maine, but recently I have come to appreciate more his paintings of man's struggle with poor conditions at sea. Information about him is not plentiful, and is written from an American perspective. It is generally acknowledged that from 1883 his seascapes become charged with a strength and drama they previously lacked.

Recently I was both astonished and delighted to discover that this new vigour was the result of his stay during the early 1880s in Cullercoats, between Tynemouth and Whitley Bay. Little has been made of this yet it is, perhaps, something we should shout about. He is one of America's greats and Cullercoats, for whatever reason, made him what he is. This seems to add meaning to the phrase 'there must be something in the water'.

On my painting expedition north I visited Cullercoats. Sadly, I found it suffering from a lack of identity, having been absorbed into the sprawl of Whitley Bay. I had also hoped for time to look round Tynemouth where there are the ruins of an eleventh century Benedictine Priory on a headland overlooking the mouth of the River Tyne. If there was a good view which included the sea

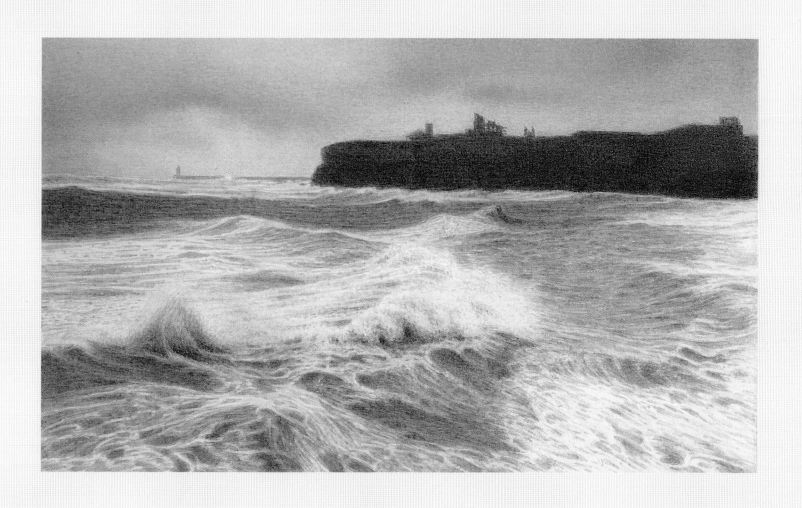

Tyne
Northerly 6, occasionally 7 or gale 8 at times.
Rain then wintry showers.
Moderate becoming good.

the Priory could be the subject for my Tyne painting, but as I would be sailing to Norway from Newcastle within two months it could be by-passed this time if the conditions were not suitable. The conditions, however, were just right; they were awful.

On my journey north a long period of intensely heavy rain had brought the motorway traffic down to a 15 mph crawl. I could not imagine getting much painting done. It would be all water and no colour, but County Durham saw an improvement. As I approached the Tyne Tunnel the lunchtime Shipping Forecast came on the car radio with a gale warning for Tyne. This was just perfect.

I found the Priory and parked on the cliff top road nearby. The howling gale buffeted the car. Clearly this was not the best time for sight-seeing. I was one of the few people daft enough to venture out into the horizontal and supersonic rain. I was immediately reminded of some of the research reading I had done for this section of my journey. The shipwreck of the *Adventure* flashed across my mind.

In the late 1770s Archdeacon Sharp of Bamburgh on the Northumberland coast was entrusted with spending, 'for the good of mankind', a considerable legacy; the Crew Trust.

Concerned about the frequent shipwrecks along that stretch of coast, he set up a life saving service. During stormy weather horseback patrols would look along the shore for ships in trouble. In 1786 the Reverend Sharp heard about Lionel Lukin, a coachbuilder of Long Acre in London who had invented and built an 'unimmergible' boat. Constructed with cork fixed round the gunwales and watertight compartments, it was designed to be unsinkable – not intended specifically for life saving. Lukin was asked to convert a local fishing boat for the Trust and this can claim to be the first lifeboat.

Three years later the Newcastle ship *Adventure* ran aground only 300 m from the shore at the mouth of the Tyne off South Shields. As the ship broke up a crowd of thousands watched in horror as, one by one, the crew fell to their death from the rigging.

Determined to prevent such a tragedy in the future, the members of a South Shields social club – the Gentlemen of the Lawe House – offered a two guinea prize for the best lifeboat design. The competition was won by William Wouldhave, the South Shields parish clerk. His design was modified and runner-up Henry Greathead was commissioned to construct the *Original*, the first purpose built lifeboat, costing just under £150.

In service at the mouth of the Tyne for forty years, she saved hundreds of lives until being wrecked herself.

Following this example the second Duke of Northumberland ordered two more boats, for North Shields and Redcar, maintained by an endowment. Henry Greathead became established as a lifeboat builder, and many bodies including Lloyd's underwriters provided funds for more boats

Tynemouth Priory à la PC

ditto
using Winslow Homer's colours

around the country. At this stage however there was no central organisation for their provision. This was established in 1824 when the National Institution for the Preservation of Life from Shipwreck was formed. In 1854 the name was changed to the Royal National Lifeboat Institution.

How appropriate, too, that the village where the first dedicated lifeboat service was established should also be the birthplace of Grace Darling, the most famous rescuer of all who used a boat similar to the one converted by Lionel Lukin.

My own adventure continued from the top of the long flight of steps leading down from the cliff top to a promenade. This curves around the bay immediately to the north of the sandstone headland bearing the Priory ruins. The sea here was breathtaking. Thunderous waves crashed obliquely against the wall of the promenade and were cast back into the path of incoming waves. The resulting collisions created foaming mountain peaks. Occasionally, a wave would clear the wall altogether and momentarily the promenade would become the sea.

The angle of the waves and the curve of the promenade allowed me to sketch the Priory while monitoring the incoming waves – hopping onto a nearby bench to avoid the flood. To try a different view I moved to another position where the waves came from behind me. I soon realised my mistake.

Fortunately the rubber mats on the floor of the car were enough to cover the seat for the journey home.

DOGGER

Whenever I meet someone and the conversation comes round to the Shipping Forecast I find more often than not that they will know the names of some of the sea areas in the right order. The strange thing is it is always the same three; Dogger, Fisher, German Bight. Why? Seamus Heaney's poem about the Shipping Forecast, from *Glanmore Sonnets – VII*, begins with four sea areas, not in sequence, three of them understandably with Irish coastlines, however the first one is Dogger.

I have two theories to offer as to why this might be: Firstly, the names are unusual, amusing even, especially German Bight, which is open to all sorts of interpretation. Put together they have a rhythm that makes them easy to remember. Like prayers from the *Book of Common Prayer*, phrases come from our past and

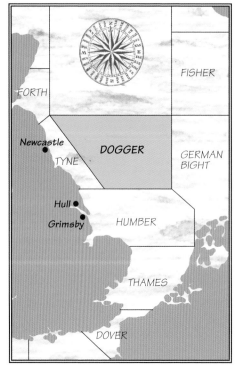

sound familiar, ringing bells and promoting nostalgia. Secondly, several sea areas will occasionally have the same forecast, which will be preceded by their names read in sequence. Maybe these three are the ones most commonly grouped together.

The Dogger Bank must be the most well known feature of the seas around the British Isles. It has been a commercial fishing ground since the sixteenth century and was probably the first known home of the beloved cod.

Dogger is a Dutch word, *Dogge*, a type of fishing vessel with two masts. The bank is extensive, being about 255 km long with an average breadth of 65 km. At the shallow, English end the sea is only 15 m deep, but more generally it is about 35 m. The shallow nature of the area has long made it possible for mariners to make accurate charts by taking soundings.

Dogger
Westerly or southwesterly 3 or 4.
Rain at times.
Moderate or good.

Soundings were taken by using a sounding line, marked off in fathoms, to which a lead weight was attached. The weight was usually conical with a depression in the base into which a dab of grease was inserted, so that when the line was dropped to the bottom a sample of material from the sea bed could be retrieved. When soundings were difficult to establish it was said to be 'hard to fathom'; another expression from the sea which has entered our everyday language.

In the Map Room of the British Library is *A Chart of the North Sea from the Forelands to North Bergen and from the Scaw to the Orkneys and Shetland. Shewing the Harbours, Havens, Bays, and Roads, Banks, Rocks, Shoals, Depths of Water &ca with the most remarkable appearances of Land. Done from various Surveys of the British, Dutch and Danish Pilots by James Thompson Mariner. 1777*. The title of this chart is almost as extensive as the Bank itself; stretching as it does east from a point just south of Hornsea on Humberside to the coast of Jutland at The Horn, between Luysberg and Blueberg, where it is called Horn Reef. The modern sea area of this name is only a small part of this.

The description on the map reads: 'On the East part of the Dogger Bank the soundings are of a fine white shade, but a little to the Northward of the East North East part the soundings are of a briskish colour. On the West part they are not so fine as on the East, nor so deep, and there are uncertain soundings with course ground in some places.' One can imagine the sailor repeatedly flinging his line over the side to obtain this

Cod on the slab

information for us. Being there I experienced a real sense of the history of the place, albeit a place without features. The sea and the sky spoke.

The Dogger Bank has been the scene of a number of naval conflicts. The earliest recorded incident was depicted 181 years after the event by J.M.W. Turner, in a painting hanging in the Tate Gallery; *Van Tromp Returning after the Battle off the Dogger Bank*.

His chosen subject comes from the summer of 1652 when a Dutch fleet fired on English ships, starting a three year conflict. This was the first of three Anglo-Dutch maritime wars in the seventeenth century which were all fought on the grounds of commercial rivalry. They were at it again a century later, in 1781, in a conflict relating to the American War of Independence.

In 1904 a most bizarre event in the war between Russia and Japan took place. The Russian Baltic fleet, on its way to Vladivostok via Africa and the Indian Ocean, came across a fleet of nearly 40 Hull trawlers fishing the Dogger Bank. For some unknown reason the trawlers were mistaken for Japanese torpedo boats, and for twenty minutes suffered a barrage of three hundred shells. The trawler *Crane* was sunk with the loss of two lives. Protests were made and the Russian Government agreed to recall the fleet, put their officers on trial and pay £65,000 compensation. The fleet was not recalled but steamed to its destruction off Tsushima in Japan.

On the day in early July that I crossed Dogger the North Sea looked as grey and as dour as I remembered it from childhood summers on the east coast. The ship's wake was the only disturbance on the water. A calm sea with only moderate visibility was to be expected at this time of year. Earlier the wind had been from the north and visibility had been much better, but as it swung round to a south-westerly we had the usual situation of warm air plus cold sea equals condensation. This light mist affected the visibility as I looked towards the horizon. At least the late afternoon sun breaking through the mottled cloud brought a splash of colour.

In this most fishy of areas my painting of the sea and the sky turned out to have an almost mackerel like quality.

FISHER

My mental picture of Denmark in relation to Britain had it positioned further south than it really is. Its northernmost town, Skagen, is as far north as Fraserburgh in Scotland. Its southern border in Jutland, with the German state of Schleswig-Holstein, once part of Denmark, is only as far south as Newcastle upon Tyne. The climate matches its latitude.

Jutland is not flat, in fact it would be more dramatic if it was. It is chalk, low lying and undulating. Its highest point, a mere 173 m, is celebrated with a tower pointing to the sky like a Victorian idea of a space rocket silo. If you want nothing but a good sandy beach this is paradise. The west coast is a 300 km long beach backed by an almost unbroken ridge of dunes knitted together with marram grass. In places where small inlets and bays once existed, the dunes have built

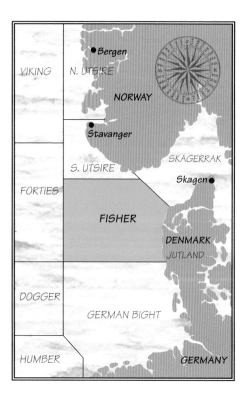

up into sand bars and spits closing them off and creating lagoons. As a result, a country where fishing is an important part of the economy has few harbours on its North Sea coast.

At low water vast areas of tidal flats are exposed which are important feeding grounds for native and migratory waders, geese and ducks, as well as seabirds of every kind, gulls, terns, cormorants and the like. This coast at low tide is an impressive sight. Seeing so many different species together was a bit like stepping into a scene from the film *The Birds*. Experiencing this while listening to the Sunday morning omnibus edition of *The Archers*, on my Test Match Special radio, was as weird as anything Hitchcock could have invented.

The sea area includes a large chunk of the west Jutland coast as its eastern boundary. Where

Fisher
Easterly 2 or 3.
Thundery showers.
Moderate or good.

Jutland sweeps away to the north-east, Fisher's boundary angles across to the north-west to join South Utsire just off the southernmost tip of Norway. To the north-east of this boundary line are six more sea areas – not used in our general Shipping Forecast – making up the waters that curve their way between Denmark, Germany, Norway and Sweden, linking the North Sea with the Baltic. They are, from west to east, Skagerrak, Kattegat, The Belts and The Sound, Western Baltic, Southern Baltic and South-Eastern Baltic.

The Fisher name is taken from two North Sea sand banks. The Great Fisher Bank lies in the western half of the area and in the eastern half is the Little Fisher Bank. On some old North Sea charts they are known as the Great and Little Fishing Banks. As their names indicate these have long been rich fishing grounds, the Scandinavian fisherman's equivalents of Dogger Bank and the Silver Pits, east of Spurn Head. Over-fishing has left them less productive than in the past, forcing the Danish fleets further afield out in the North Sea and the Baltic.

For those wanting a fix of Fisher there is the Scandinavian Seaways service from Harwich to Gothenburg, which comes with a good dose of Skagerrak. That was too easy for me, I used the Denmark to Faeroes route.

Most of my time on this voyage was spent patrolling back and forth, side to side across the decks. Why are the best views always on the shady side of the ship? On a long voyage in open sea a sudden sparkle of sunlight, a fleeting glimpse of something in the water, can be just the defining moment that makes one sea area experience different from another. I did not want to miss anything. Neither did the Captain, so it seemed, as a Norwegian trawler crossed our bows less than two ship's lengths away.

Like the captain's, my vigilance paid off. Something quite unusual happened.

The sky was clear and blue, apart from a few thunder clouds building up on the horizon and the sea was a deep rich blue. Blue water in the North Sea! I cannot remember seeing that before. Along with this rare vision of blueness came a more common sight for these waters, but something I had not witnessed before. In varying bands of about two or three metres wide and at right angles to our course, stretching out to both horizons for several kilometres and colouring the sea a vivid orange-red, were plankton tides.

Plankton is a collective term for a variety of microscopic freshwater and marine organisms that are found at or near the surface of the water, but are bottom of the aquatic food chain. Plankton can be plant or animal and at this level of existence the division can become a little blurred. Without removing a sample to have it analysed, precise identification would have been impossible so in this case an educated guess would have to suffice.

The colouring would not provide a clue, as the varieties of either type that are likely to be found in the North Sea could contain the same colouring

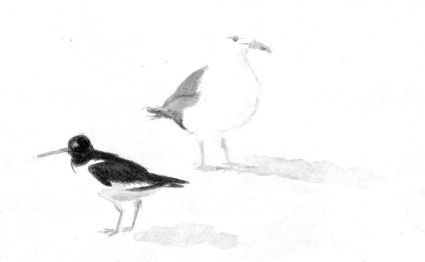

Oyster catcher & Lesser Black Backed Gull

element; beta carotene. The best guess is, some form of chlorophyceae if they have plant like leanings, or noctiluca if they have animal tendencies. For the water to have become coloured there must have been a sudden blooming of organisms which were then carried by the movement of surface water, caused by the wind blowing from the same direction for a good period of time.

All this science is fascinating to me. It is my belief that artists and scientists are similar beings – trying to make sense of the world and beyond.

We are constantly observing, analysing, challenging and being creative.

Once again on my journey around the Shipping Forecast I was to experience that thrill of finding an image that I could take back with me to my studio. The process of learning about things around me is always hugely interesting. Knowledge picked up does much to inform my work.

I take a long time – about a week of solid work – to finish each painting and have time, therefore, to muse on many things.

GERMAN BIGHT

Whenever the total loss of a ship is reported at Lloyd's of London, the insurance exchange in Leadenhall Street, the Lutine Bell is rung once. When a ship is overdue it is rung twice.

The bell has become famous and its sounding strikes fear into many a heart. It is not only mariners who listen avidly to the Shipping Forecast. I suspect that many a City gentleman has also listened with some trepidation, knowing that he will have to pay out a fortune if one of the ships he is insuring is lost.

The bell comes from *HMS Lutine*, a captured French warship which was recommissioned by the British before being later lost. Not only was this bell put to good use, but the ship's rudder was made into the official chair for the chairman of Lloyd's with enough left over for a secretary's desk. The rest of *HMS Lutine* has been

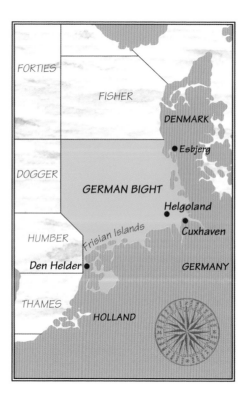

in the sands of the West Frisian Islands off the Dutch coast since 9 October 1799.

La Lutine was built in Brest in 1785 for the navy of Louis XVI of France and was surrendered to the Royal Navy eight years later, eventually becoming part of the North Sea Fleet. In 1799 Britain was still at war with France. Large sums of money were routinely ferried across the southern North Sea to pay the soldiers. On one such trip an additional sum of about £600,000 was to be carried for some City of London merchants. Their businesses in Hamburg were in difficulties because of the disruption caused by the conflict.

The money, in gold and silver, was put aboard the *Lutine* at Yarmouth, together with the mail for Hamburg and Bremen, and she set sail in poor weather for Cuxhaven at the mouth of the River

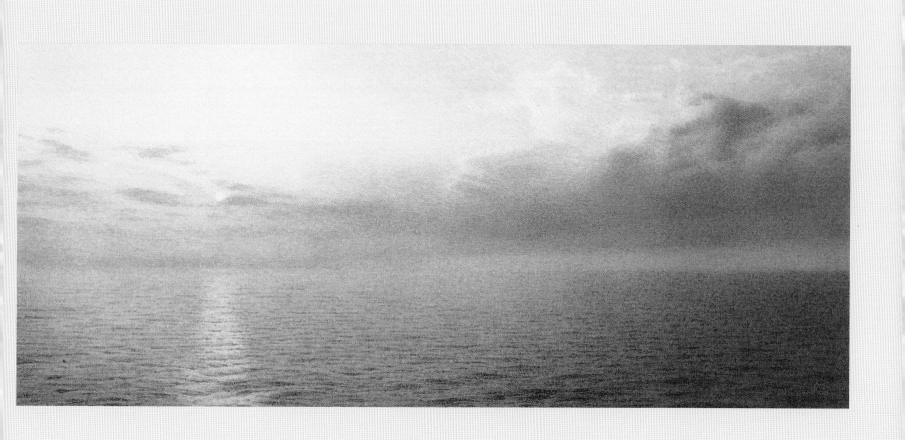

German Bight
Southeasterly becoming variable 3 or 4.
Thundery showers.
Good.

Elbe accompanied by *HMS Arrow*. The weather rapidly worsened and became a north-northwesterly gale. In the night the *Lutine* was driven onto sands and broke up. The only survivor was one crewman out of 250, and he died soon after.

It was a black day for the Lloyd's underwriters. Sand rapidly covered the remains and it was not until 1857 that the bell and rudder were salvaged. They found a fitting resting place in the City of London.

German Bight should not be confused with the dog popular with the police, armed forces and security guards or the beer Holsten Pils. A bight is a wide indentation of a shoreline, or the body of water bounded by such a curve. The German Bight, in geographical terms stretches from the Dutch town of Den Helder in the south-west, to the Danish port of Esbjerg to the north-east, a distance of 360 km as the gull flies, or about 550 km if the coastline is followed.

The furthest point from the direct Den Helder-Esbjerg line is Cuxhaven, 120 km to the south-east.

In the middle of the bight, 70 km off Cuxhaven, is the small island of Helgoland, which we in Britain call Heligoland. For some this name might have a familiar ring about it. Until 1956 it was the name given in our Shipping Forecast to this sea area, but as that was only known in Britain it was decided to use the one by which the area was known on the other side of the North Sea; German Bight.

The small island is surrounded by steep, red sandstone cliffs, which, according to legend, were brought here from Norway by the devil. Until 1714 Helgoland belonged to Holstein, and then to Denmark until it was ceded to Britain in 1814. In 1890 it was transferred to Germany in exchange for Zanzibar. My journeying pales into insignificance when compared to this movement.

The whole of this extensive coastal region is very low lying, with some areas even below sea level. This is especially so in the northern part of Holland where the country's total land area has been

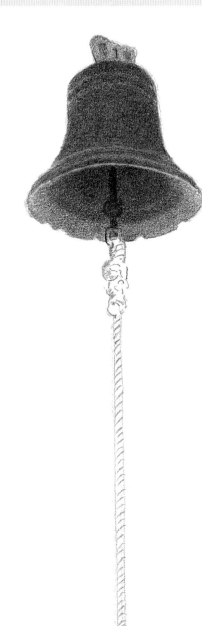

Lutine Bell

increased by twenty per cent through reclamation projects. There is an old Dutch saying, God created the world but the Dutch created Holland. It has not always been gain, however. The people living along this coast have a capricious relationship with the sea. It has provided them with a good living, at times great wealth, but has also been destructive with many inundations throughout history.

There is also a more realistic German phrase, *Nordsee ist Mordsee*. Literally, this means the North Sea is murderous.

Offshore and forming a broken belt right round this coast are the 42 Frisian Islands, which were once the dunes that made up the continental coastline. Now they are separated from it by extensive tidal shallows. Although they are all at the mercy of the sea and there is a constant battle to reduce erosion, they are well populated and have their own distinctive character. Some have become known as the German Riviera.

Before my sail through German Bight on the Esbjerg to Harwich ferry I spent a baking hot day on the northernmost island of Fanø. Dunes, conifer plantations, small farms and pretty painted cottages with thatched roofs were there to be enjoyed. Bicycles outnumbered the cars by about five to one and the combined width of the footpaths and cycle tracks equalled that of the roads – which I found to be a very civilised state of affairs.

The seaward side of the island is a long white sandy beach which is so firm that motorists drive their vehicles onto it. This is especially useful, as the stretch of sand is so wide you would need a car to reach the sea if you fancied a swim.

From the deck of the departing ferry the low-lying land looked insignificant and vulnerable. It soon slipped over the horizon. Only the tall white chimney of Esbjerg power station, with its flashing navigation lights, remained visible for any great length of time as we sailed off into a glorious sunset.

HUMBER

If you have ever wanted to make one of those conversation stopping statements that no-one has an answer for, try this one: At any given moment the waters of the Humber hold in suspension two million tons of sediment.

This vast volume of silt and fresh water exists because five major rivers drain into the Humber estuary. They themselves drain almost one quarter of the area of England. A fierce ebb tide carries this solution down the estuary to where the Humber meets the North Sea at Spurn Head. When the tide slackens the sediment is dropped creating areas of constantly shifting sandbanks and channels which need to be surveyed every two weeks to keep the area safe for shipping.

This is an area of necessary lighthouses, buoys, lightships and beacons.

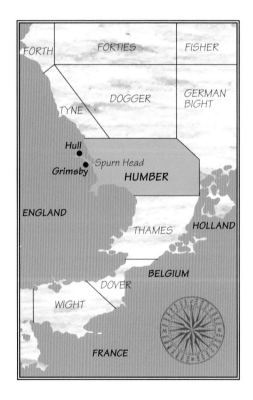

Most of us associate the Humber with deep-sea fishing. Great fleets of trawlers and drifters once sailed out of Hull and Grimsby in search of the cod and haddock which fuelled our beloved fish and chip shops throughout the land. This, though, has been a relatively recent development. Until the mid nineteenth century Hull was Britain's main whaling port. Its factories processed the valuable blubber into oil for lamps, for lubrication and as an ingredient for soap and paint. The flexible plates of bone in the whale's throat, through which it sieved its food, were made into corset stays, umbrella frames and chair backs.

Coincidental with the decline of whaling was the discovery of the rich fishing grounds of the Dogger Bank and later the Silver Pits by West Country fishermen who had worked their way up

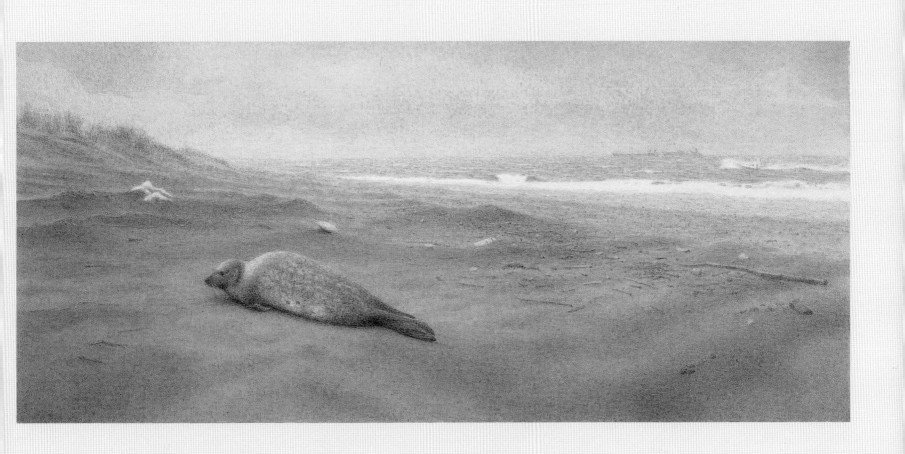

Humber
Southeasterly 5 or 6, decreasing 4 later.
Occasional rain.
Moderate or good.

the English Channel into the North Sea in search of better catches. Needing somewhere close to land their catches and maintain their boats they eventually made the Humber ports their base.

There is more to the Humber's maritime past however than whaling and fishing. In the Town Docks Museum in Hull I found the oldest plank-built boats in the world outside Egypt, dating from about 1500BC. I was also to discover that it was from a creek at Immingham in 1608 the Pilgrim Fathers first sailed from England in search of religious liberty.

Spurn Head was an obviously good place from which to paint Humber. The Spurn peninsula is a narrow spit of sand and shingle curving five kilometres into the Humber estuary. Only about 50 m wide in places, it has no rocky base and has been created out of the silt deposited by the Humber tides along with material eroded from the cliffs of Holderness to the north. The nature of its construction means that it is constantly shifting with its loose accumulation of material held together by the marram grass which grows where the sea does not reach.

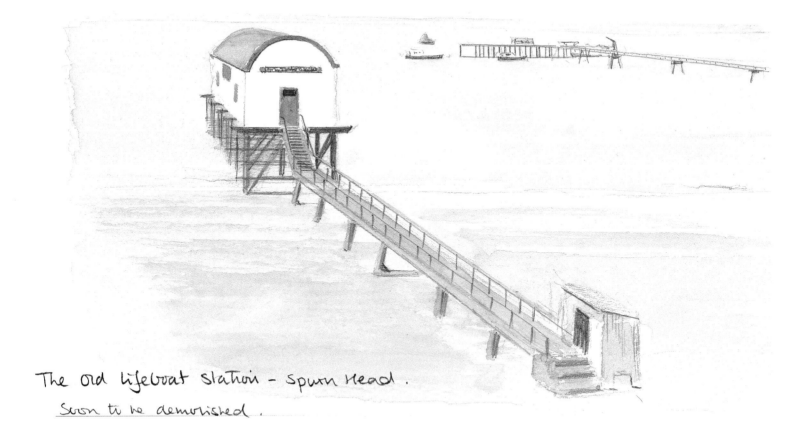

The old lifeboat station – Spurn Head.
Soon to be demolished.

A narrow concrete road took me to a car park just beyond the lighthouse and within a few hundred yards walk of the end of the spit. To the left of the road are mostly dunes and beyond is a wide sandy beach and the North Sea. To the right are the mud flats of the Humber estuary. Man has recently given Spurn back to the sea – officially – and will in future allow nature to take its course. It is expected that the land will move westerly at a rate of about two metres each year.

I arrived late one grey and wet Friday morning in February. A strong onshore wind had blown sand across the road , and the heavy rain had caused some flooding. I noticed that the road is zigzagged by short sections of narrow gauge railway which presumably at some time ran as straight as the present road. Beyond the car park access is on foot only, to a group of modern buildings, the homes and offices of the Humber pilots and the Spurn lifeboat crews. A jetty leads out to their moored launches and beyond that is an earlier lifeboat station with a ramp down which many a rescue must have been launched.

Spurn Head is so inaccessible that the lifeboat crews are unique in the RNLI – being full time. The nearest village, Kilnsea is six kilometres away.

I later discovered that the railway ran from a military establishment there to another at Spurn Point and that the lifeboat crews made use of it by travelling on a sail propelled trolley. Stopping was difficult but necessary since the trolley ran unofficially between the army's trains and had to be lifted clear when a train was sighted. Such is the dangerous life of the lifeboat man – and that is before he gets onto the water.

From the car park I scrambled over the dunes to the beach. A strong wind lashed the rain almost horizontal. Behind me stood the striking black lighthouse with its wide white belt.

I set off in the direction of Spurn Head and even making this short walk I was thoroughly soaked, if only down my left side. My right side at this point was still fairly dry, but I did not doubt that the walk back to the car round Spurn Head would even things up.

As I rounded the corner the end of the pilots' jetty came into view with a launch just leaving. Surveying the scene, I had a strange feeling that I was not alone. The pilots' launch set off in the direction of the cargo vessels and I turned around to notice a seal lying at the high tide mark. Here was my sensed companion, probably left behind by the receding tide.

Suddenly I felt a painting coming on.

Back home in my studio when I was finishing this painting I heard on the radio that, driven by gale-force winds, the North Sea breached the Spurn peninsular and Spurn Head became an island, stranding the Humber lifeboat crews, the pilots and their families. They, like the seal, had once again discovered the unpredictability of the elements.

THAMES

Growing up in North-ampton meant that the sea did not figure prominently in my life; it is about as far from the sea as one can get.

Learning more about the sea and its traditions has been a revelation. Here in the Thames sea area, for example, I found that from October to March, 14 drifters from the West Mersea area of Essex sail out into the Thames Estuary on day-long fishing trips, using methods virtually unchanged for a century. Their nets are left to hang curtain-like in the water for several hours. The mesh is of a size which will discourage large fish and allow small fish to swim through. A mature herring of two years or more will get its head through the mesh but its body will be too big. Unable to reverse out because of its gills the unfortunate fish (very good baked with a

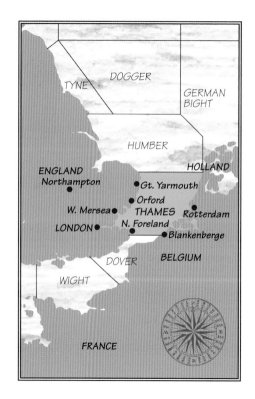

bacon and mushroom stuffing) becomes trapped. Ecologically sound, these drifters have a total quota for the year of 131 tonnes, a catch a large modern trawler will indiscriminately vacuum up in an hour.

The Suffolk stretch of coast-line in this area is constantly changing, with the forces of erosion and deposition at their most active. Saxon Dunwich was a flourishing port, important enough to have a bishop and a grammar school. In Norman times it became the most prosper-ous town in Suffolk, with three churches and a 5,000 strong pop-ulation. The sea gradually undermined the soft cliff which occasionally collapsed, sometimes taking with it whole streets, and by 1677 the sea had reached the market place. It is now a hamlet of Victorian estate cottages. Old Dunwich has only archways of a medieval priory and a leper chapel left.

Thames
Variable becoming westerly or southwesterly 3.
Showers.
Good.

A short distance down the coast the opposite has been occurring. At one time the medieval coastal town of Orford was considered important enough for Henry II to build an impressive castle. The gradual south-westerly growth from Orford Ness of a shingle spit has cut off the village, now 2 km from the sea across the shingle, 8 km down the River Alde.

The responsibilities and activities of the Corporation of Trinity House are many and varied. The organisation is led by a Court of Elder Brethren, who were initially given powers to regulate pilotage in the River Thames by a Royal Charter granted by Henry VIII in 1514. Most people will know them today as the organisation which operates and maintains the lighthouses and light vessels in England and Wales. They are also responsible for saving the remains of the twelfth century St. Mary's Church, Reculver, on the site of a former Roman fortress, Regulbium on the north Kent coast.

The twin towers of the church, known as the Two Sisters, were a great landmark for shipping in the Thames Estuary. By the early nineteenth century the sea had removed half of the Roman fort and was beginning to undermine the church causing a greater part of the main body to collapse. To preserve the towers as a sea-mark they were purchased and restored by Trinity House. The sea which now surrounds them is of caravans.

The western extent of Thames is the coast of East Anglia south from a point between Cromer

Reculver ruins

and Great Yarmouth, and the north Kent coast to North Foreland. This however is not the only stretch of Thames coastline. On the eastern side the area takes in the Dutch coast south from Den Helder and the Belgian coast as far south as Blankenberge, which in my household is the name given to the pink and yellow chequered sponge cake with a marzipan coating. At the centre of this stretch of coast is Europoort at Rotterdam, one of the most important ports in the world, able to handle the largest ships and with direct links to the Rhine and the industrial Ruhr region. Sadly the rise of Rotterdam has seen an equal decline in the status of the Thames, hardly recognisable now as a great maritime river.

I find the most striking example of the Thames' changing fortunes in the Greenwich and Docklands area. At Greenwich we can see the Cutty Sark, Sir Christopher Wren's former Royal Naval Hospital framing so well Inigo Jones' Queens House, which is now part of the National Maritime Museum, and Sir Richard Rogers' Millennium Dome. Across the river is the Isle of Dogs and the former docks, named East India, Albert, Victoria and King George V; each one specialising in a particular cargo – 70 km of quayside once operated by an army of dockers, surviving now only in street names such as Pepper Street and Lightermans Road. Mixed in with the stevedores terraces are warehouses converted into television studios and bijou flats for the well-heeled.

For me the symbol of this past glory is the Thames sailing barge. I lived in London in the mid 1970s and a day in the Essex countryside brought welcome relief from the relentless drone of the London traffic. One of the most attractive places was Maldon. Although not on the coast, but on a broad tidal river, the small town has a nautical air and it seemed that all the Thames sailing barges still in existence were moored there. Twenty years after moving from London I caught my next sight of Essex from the deck of the ferry bringing me back from Esbjerg, where I had been to paint German Bight. As the ship approached Harwich it passed the first Thames barge I had seen under sail in the Thames Estuary.

This was such a good welcome home sign it seemed to be the perfect image for Thames.

DOVER

The continuous stratum of chalk marl under the narrowest part of the English Channel suggests that at some time Britain and France were connected across the 34 km that now separate them. The white cliffs that have been created on both sides by the erosion of that stretch of land are visible from each other, but those around Dover have become a symbol of England and its separateness from the continent which lies beyond those on the French side.

Because of the short distance between them this has long been the focus for Channel crossings whether they be in peace or in anger, which has led to Dover becoming both Britain's most heavily fortified town and busiest ferry port.

Had Julius Caesar the option of commandeering modern roll on/roll off chariot ferries for

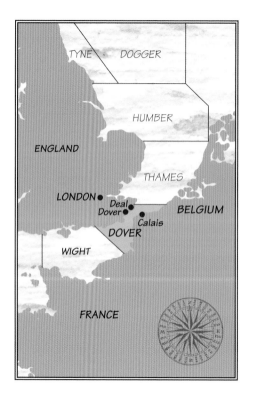

the first recorded invasion, he could have made the crossing with a mere five vessels and provided his army of six thousand with pizza and cappuccino (the real Italian invasion) on the way over. The eighty sail and oar driven galleys which landed in 55 BC set a precedent followed by others for two thousand years. They gave the new headquarters of their northern fleet, the *Classis Britannica*, the name Dubris and on the cliff top built a lighthouse to guide their supply ships ashore.

The impressive lighthouse, or pharos, now enclosed within the considerable fortifications of Dover Castle, was Britain's first and is comparable to the Roman tower at La Coruña in north-west Spain, in sea area FitzRoy, the oldest lighthouse in the world still working. The octagonal four storey Dover pharos, constructed of flint rubble, was originally

Dover
Easterly or northeasterly 3 or 4 occasionally 5 at first.
Fair.
Good.

Pharos, Dover Castle

faced with stone and may have been twice the height, with an open brazier for the light.

No doubt the pharos was positioned to help them avoid the Goodwin Sands, a constantly shifting sand bar 16 km long and 8 km wide lying about five miles off Deal. At 25 m deep and partly exposed at low tide, the Goodwins have proved to be a major hazard. Ships still manage to run aground with disturbing regularity despite the fact that the Sands are protected by ten warning buoys and three Trinity House light vessels. A ship can run aground when the sands are covered and break its back as the tide falls, being swallowed by the sand in a matter of hours.

At low tide the Goodwins occasionally reveal their victims; the German submarine U-48 which sank in 1917 has reappeared in 1921 and 1973. Also regularly seen are the masts of two American ships which foundered in 1946. Nowhere in the world is so much lifeboat cover concentrated into such a small area, with no less than seven stations scattered along the coast to enable any part of the Sands to be reached quickly. Surprisingly the Goodwins have their lighter side. In 1854 two teams played a cricket match at low tide and the event has been repeated several times by Royal Navy teams dressed in nineteenth century costume.

Safety considerations are unlikely to be the reason for the various attempts, some successful, to cross the Channel without the aid of a water borne craft. In 1875 Matthew Webb became the first person to swim the Channel and in 1909 Louis Blériot completed the first crossing by air.

In 1802 Albert Mathieu-Favier, a French mining engineer, drew up a plan for a tunnel, with ventilation chimneys reaching above the waves and utilising an artificial island built on the Varne sandbank near the mid point. This had to be abandoned when hostilities between Britain and France again broke out. Along the foreshore near Shakespeare Cliff are the abandoned workings of a tunnel begun in 1880. Tunnelling was resumed in 1922 but soon abandoned again. In 1975 work stopped on yet another tunnel consisting of two shafts 740 m long. The present tunnel – now so taken for granted – is based on a scheme drawn up in 1960.

I began my journey to Dover on board *Le Shuttle* through the tunnel at the end of a family holiday in Bruges. On our arrival we drove around for some time looking for good views and an interesting angle on the castle, feeling good about being in a hilly landscape again. We eventually stopped for a break in the National Trust's car park on Langdon Cliffs. It was a warm, clear, summer evening with the white of the cliffs at Calais just visible on the horizon. We looked down into the harbour at the staggering amount of cross Channel traffic.

Refreshed, we moved on, taking the minor road towards St. Margaret's at Cliffe. I had gone with an open mind as far as the subject matter was concerned; the Roman pharos, the castle, the white cliffs. Somehow I hadn't imagined it would turn out to be the ferries, but as we drove along that cliff top road, passing a recently harvested barley field, they suddenly caught my eye and I realised that this was the painting.

WIGHT

I carry around in my head two alleged 'facts' about the Isle of Wight. You never know when they will come in handy. The first is that the whole population of the world can fit onto the island. If this is so I would like to be a ferry operator when they arrive because the second alleged fact is that the journey there from the mainland is, in fare cost per kilometre, the most expensive ferry journey in the world.

To make that journey one is spoilt for choice as there are about 350 crossings a day. The shortest distance is from Lymington, in the New Forest, to Yarmouth. The quickest crossing is by hovercraft from Southsea to Ryde, a mere nine minutes. A similar route, from Portsmouth to Ryde or to Fishboune is taken by the more conventional ferry. From Southampton a catamaran skims down

to Cowes in about 20 minutes and a large vehicle ferry does the same trip, but into East Cowes, in about an hour. I chose the latter, opting to cruise down Southampton Water as if on the deck of one of the great transatlantic liners that once started their voyages to New York in such a manner.

As the ferry entered the Solent it passed the Group 4 yacht practising for the BT Global Challenge, the 'round the world the wrong way with an amateur crew' race. My first thought was, could this be Parkhurst Prison Sailing Club?

The islands around Britain all have their own particular character which distinguishes one from another but collectively they all share common attributes, a sense of community, a quality of life, a definite feeling of being away from the hurly-burly of the mainland.

Wight
Variable 3 becoming southwesterly 4.
Occasional rain.
Moderate or good.

The Isle of Wight struck me as being somewhat different. In many ways it is southern England in miniature, the landscape, the towns and villages, the general atmosphere more like the mainland than any island I have visited; Dorset cast adrift.

The Wight landscape has great variety, creating a coastline that has a little bit of everything. A series of different geological strata run east-west across the island, the most prominent being a ridge of chalk downland across the centre, the thickest chalk beds in the country, forming the high cliffs of Tennyson Down at the island's western end – a sheer white wall. The Down is named after Lord Tennyson who lived nearby and frequently walked there, where the air was 'worth sixpence a pint', that is 2·5p per 570 millilitres for those who only understand metric.

The band of chalk was once continuous with that crossing the misnamed Isle of Purbeck to the west. Wight was created when the sea breached the chalk ridge flooding the low land beyond, leaving a series of stacks as remnants; the Needles off Tennyson Down and Old Harry Rocks off Purbeck. Both these groups are quite a spectacle when seen from the cliffs overlooking them, but are even better from the sea.

The view of a cloud capped Tennyson Down seen from the east across Freshwater Bay became my painting for sea area Wight.

Immediately to the north of Tennyson Down stand the unique cliffs at Allum Bay, sandstones, clays and shales in closely packed vertical bands creating multicoloured buttresses from chocolate brown to strawberry pink. To the north beyond the

Newtown Town Hall

attractive little town of Yarmouth is a nature reserve of salt marshes and narrow creeks, once the port of Francheville, later Newtown, laid out in 1255 as a new settlement. A few cottages survive, surrounded by a series of grassy streets and the rectangular plots of former neighbours. It is quite a shock driving along a narrow country lane and coming across the old Town Hall standing isolated at the roadside, a most incongruous sight.

For most people who know the sea area, Wight means the Solent and sailing. It is full of characters such as Helen Tew, now in her mid eighties, who has been sailing since she was 11, so has more experience than most. I visited her at her home in the New Forest between the Beaulieu River and Lymington where the Solent comes to within 10 m of her back door. We sat in her house, full of sailing images, and looked out across to Newtown, while near to the shore two small fishing boats trawled for oysters.

Helen was born into a sailing family. Her father Commander R. Douglas Graham RN was thought to be the first man to sail the Atlantic single handed and regularly wrote of his sailing exploits in the Royal Cruising Club Journal. When she was 17 they sailed together from Bridgewater to the Faeroe Islands in a seven tonner *Emanuel*. She wrote of the voyage in '*The Adventure of the Faeroe Islands*' published in 1932.

Her husband was a boat designer and work in Lymington brought them to her waterside home in 1951. She has been sailing the Solent from there ever since. She has seen a big increase in the popularity of sailing, especially since the introduction of fibreglass construction which has made boats more affordable. Unfortunately, she feels, this has led to an increase in the number of people who treat their boats as cars, having less regard for the rules and conditions than they should. The Shipping Forecast, it seems, has never been more necessary.

With two elderly friends Mrs Tew is now famous locally as one of the 'sailing grannies', with a combined age of nearly two and a half centuries and with 25 grandchildren between them.

For most of their lives they have been avid listeners to the radio forecasts – plotting their extraordinary voyages according to what they hear.

PORTLAND

Until recently my every-day car was a 1960 Vauxhall Cresta. It is hard to quantify the appeal of something like that. I had no general interest in cars of any age. I just saw it parked at the side of the road one day, olive green and dripping with chrome, with its sparkling grill grinning like someone who has just enjoyed their first jaffa cake. I must have that car, I thought to myself.

It was 18 years old at the time and I kept it for another 17. I saw it as a great piece of industrial design. I imagined sitting at my desk with a blank piece of paper, picking up my pencil, as if I was about to start a new painting, and instead creating that. That curvy roof line, those wrap around windows, the way the chrome strips along the tops of the fins became indicator housings at

one end and rear door handles at the other; brilliant.

It was appropriate then that I went to Portland in the Cresta, because there is a feeling there of stepping back in time.

The timing of the visit was dictated to some extent by the car. I wanted to make the round trip in a day, which meant setting off at six in the morning, but as this was December I did not want to go out in an early frost. The heater was less than adequate. Although legal, and as good as they could be on a car of that vintage, by modern standards the steering was a bit sloppy and the brakes a little vague. In the wrong conditions it could feel like driving across Spitsbergen rather than Dorset. So early one mild, dry Saturday just before Christmas I set off. Overnight rain had left the country roads grimy and wet. I arrived soon after sunrise

Portland
Northwesterly 4 backing southwesterly 5.
Rain later.
Good becoming moderate.

looking as if I had just driven off the nearby tank range.

Geologically, and in its character, Portland is an island; a huge slab of limestone 7 km long and 3 km wide, tilted, so that at the northern end there is a 120 m escarpment which slopes gently almost to sea level at the southern tip. This is the Bill. In reality the island is joined to the mainland at Weymouth by Chesil Bank, one of the natural wonders of Britain. The Bank is a 17 km long crescent of shingle, in places 12 m high and graded, so that at the western end the stones are the size of a pea but at the Portland end about as big as a fist. The Weymouth to Portland road runs alongside the Bank and as one approaches the island it is easy to see why Thomas Hardy called it the Gibraltar of Wessex.

In shadow for most of the day, the towering cliff looks grim and forbidding. Through the town of Fortuneswell the road zigzags up this rock face and the view from the top is spectacular. On a clear day much of the English coast that is within the Portland sea area, from Start Point to Swanage, is visible.

Portland is surprisingly densely populated, with four main communities and several small scattered groups of buildings. Fortuneswell and Southwell give away their origins in their names. Between them, and now merged into one, are the rather unimaginatively named villages of Easton and

The Cresta, Isle of Portland

Weston. On the whole these villages have an austere look about them, an unrelenting greyness. More significant are the holes in the ground which surround them. With names like Silklake and Suckthumb these are the Portland stone quarries which have, over the centuries, given birth to many grand buildings like St. Paul's Cathedral and the home of the Shipping Forecast, BBC Broadcasting House.

After Southwell the panorama of Portland Bill opens up with the English Channel as a backdrop. In the distance, at the most southerly point on the 'island' stands the elegant Edwardian lighthouse with its distinctive red cummerbund. Closer, and a surprise for the first time visitor, is a second mid Victorian lighthouse which is now a bird observatory. A third, built at the same time and converted into a house, stands to the west of the observatory near the cliff top.

The active light, along with every other lighthouse in the country, now operates automatically and therefore needs no full time crew. However, all land based lights have a part time guardian, usually an ex-lighthouse keeper, who looks after the building and performs routine maintenance like cleaning the lens. In a few instances, and Portland is one of them, they will open the building for public viewing – thoroughly recommended if you have the stamina to climb the tower.

From the lantern room are good views. Out to sea is the Race, where the tides from Lyme Bay and Weymouth Bay meet – causing, even on a calm day, a violently churning area of water just offshore. In the opposite direction, along the east coast, are the remains of the jetties where Portland stone was once loaded onto ships. Around the Bill are a gaggle of wooden buildings; boathouses, holiday chalets and a cafe. This was boarded up for the winter – just when I needed a warming cuppa.

PLYMOUTH

The many great voyages of endeavour and discovery that have begun or ended in Plymouth have made this the most famous port in seafaring history. So where was the maritime museum? My great voyage of discovery in search of it proved to be as fruitless as Frobisher's to seek the North-west Passage to the Orient. There wasn't one.

Plymouth started life as the fishing village of Sutton and the harbour around which the city has grown still bears that name. Its location near the entrance to the Channel, and its great natural harbour together with the patronage of Drake, Gilbert, Hawkins and Raleigh made it the base of the English Navy during the sixteenth century Spanish Wars. In 1689 William of Orange established the Royal Navy dockyard at Devonport, then marshland to the west of the town, and it has been there ever since.

Around Sutton Harbour is the Barbican, an area of narrow sloping streets, the site of the original town which Drake and Raleigh would have known. One of the oldest buildings is the Customs House, built while Drake was away plundering Spanish colonies in the West Indies and Florida. According to tradition, on his return from this particular voyage he introduced tobacco to England. I wonder if he visited the new building to declare his cargo?

A memorial marks the point from which the Pilgrim Fathers departed on the final leg of their journey to America, naming the sight where they went ashore Plymouth Colony. Had everything gone according to plan it is possible there would not be a Plymouth in Massachusetts. The original

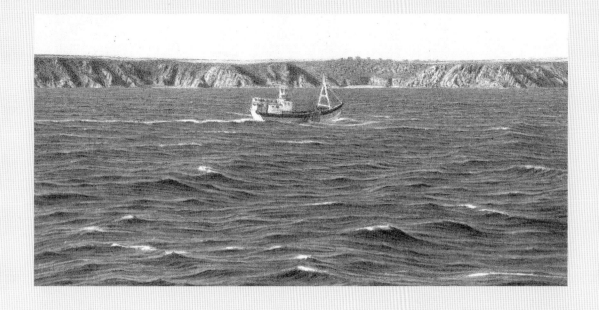

Plymouth
Easterly 3 or 4 increasing 5 or 6.
Thundery showers later.
Moderate or good.

Fishing boats
tied up in
Sutton Harbour

departure on that voyage had been from Southampton. Doubts about the seaworthiness of the *Speedwell* forced them into Plymouth where it was decided to complete the journey in the *Mayflower* alone. They had been authorised to settle in Virginia, but bad weather and poor navigation found them two months later off Cape Cod.

To the west of Sutton Harbour, beyond the seventeenth century Citadel is the Hoe, a large area of open parkland on a sloping site, with panoramic views across Plymouth Sound with the English Channel beyond the breakwater. Dominating the Hoe is all but the base section of John Smeaton's eighteenth century Eddystone Lighthouse.

The Eddystone Reef lies 22 km south of Plymouth and has been journey's end for many ships. The first lighthouse was built there in 1698 by Henry Winstanley, an Essex ship owner who lost two of his own vessels on the reef. Five years

later, while he was carrying out repairs, a great storm washed away both the tower and its unfortunate builder. Smeaton's granite tower, the fourth on the reef, was the first anywhere to be constructed of stones dovetailed together for strength. It stood for 120 years and was only removed to the Hoe because the rock on which it stood was being undermined by the sea. I was tempted to consider the red and white tower as the subject for a painting, but it would be too easy to let these travels of mine become 'lighthouses I have seen'.

To the north of the Hoe is the modern city, completely rebuilt to a new plan after the heavy bombing of 1940–3. It was a brave decision not to reconstruct the old townscape as so many other places have done, although few suffered such comprehensive destruction. Sweeping away from the Hoe is Armada Way, the main thoroughfare through the new city centre.

Never before have I seen so many 1950s buildings together. I am a fan of 50s modern when it is successful, unfortunately in 95 per cent of cases I fear it is not. As individual buildings go Plymouth is no exception, although the NatWest Bank is exceptional of its type. As a piece of city planning it is more successful, and works best in the square next to the Civic Centre skyscraper, with trees, seats, water and, blissfully, no traffic. I sat here in the warm sunshine with my lunch, along with hundreds of office workers and shoppers. It was like being in another country.

I had visited Plymouth on a return journey from the Isles of Scilly, travelling by train along the old Great Western line from Penzance. As the train leaves Saltash station to make the short journey across the River Tamar into Plymouth, passengers on the south side of the carriage get a splendid view of Brunel's magnificent Royal Albert Bridge, carrying the line over the river and which brought Cornwall into the railway age. To the west the little Cornish bays and tree lined creeks I had just passed gave a glimpse of how the Plymouth area would have been in the days of Sir Francis Drake.

The coast of Cornwall, which makes up the major part of the northern boundary of the sea area, looks almost deserted from the sea, with no major development on the scale to be seen along most of the English coastline. It is a cliff lined coast of rocky headlands, wide bays, innumerable pretty coves and settlements with uniquely Cornish names; Mevagissey, Coverack, Gunwalloe.

While on the the ferry from the Scilly Isles we had passed Land's End and were joined on our journey to Penzance by a French crabber, not after crabs at all but langoustine.

I leaned against the handrail of the ferry for some time, watching as we slowly overtook this interesting craft. We were almost alongside before it dawned on me that I should really be sketching this scene. Here were the two elements for my painting of the Plymouth sea area; the modern fishing boat set against a backdrop of the timeless coastline.

BISCAY

The Bay of Biscay has a fearsome reputation. The Romans called it *Sinus Aquitanicus* and dreaded its heavy seas. Apparently the name Biscay comes from Biscaine, the old name for the Bordeaux region when, in the fourteenth century, it was briefly English territory.

Crossing it on my hitched voyage on the Royal Research Ship *Discovery* took 36 hours. We were halfway across at sunrise – and what a sunrise! The sea was flat calm and the only disturbance was the ship's wake.

I sailed through Biscay, Trafalgar, Finisterre (as FitzRoy was then known) and Sole on a seven day voyage from Santa Cruz de Tenerife to Barry. This trip came as a bit of a surprise. I was painting away in my studio when I received a phone call from a friend who as a puller of strings is grade one listed.

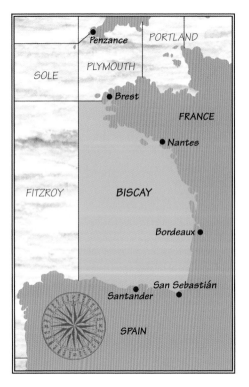

'Are you free next Wednesday?'

'Not now I suspect.'

'And for the following seven days?'

'This sounds serious.'

'Well, if your passport is up to date, you can fly out to Tenerife to join the *Discovery* which is sailing back to Barry from Cape Town. Some engineers are flying out to join it and you can go with them.'

I'll admit to having been a little apprehensive, especially after I discovered that we were to board by ship to ship transfer.

That experience was not as bad as I had expected. The things one does for one's art...

The *RRS Discovery* is a scientific survey vessel belonging to NERC, the Natural Environment Research Council. They operate seven ships including two for the British Antarctic Survey. The present *Discovery* is both the third and fourth ship to bear that name (after a rebuild). The first took

Biscay
Variable 3 or 4.
Fair.
Moderate occasionally poor.

Scott to the Antarctic and is now moored at Dundee where it was built.

Much of its work involves lowering scientific equipment into the sea either while the ship is in motion or from a fixed station. To facilitate this it is fitted with a considerable amount of lifting and winching gear. In order to keep the vessel in balance and to provide a large enough side deck to work off, nearly all of the superstructure – the workshops, laboratories, offices, cabins, and even the funnel – are to the port side. The starboard deck makes the external link with the fore and aft areas of the ship.

Looking from this deck to the white painted bridge and the cabins below, with their accompanying walkways, steps and handrails, there is an architectural quality reminiscent of those small art deco hotels you find at seaside resorts like Bournemouth or Torquay. This is curiously reassuring, but pitching and rolling on the high seas I doubt if Great Aunt Alice would take her holidays here. When the sun is out the shadows move around in a most disconcerting way.

Mid morning we stopped for some tests to be carried out on a faulty winch and remained stationary for nearly seven hours. We were obliged to warn other shipping that we had turned the engines off and therefore could not undertake any manoeuvres. One would think with today's technology that this might have involved transmitting a signal, an electronic beacon maybe. But no, a small collection of wicker baskets of differing shapes was run up the mast.

I understood that our activities might attract the attention of some wildlife. The horizon was barely discernible in the bright hazy light. With the calmness of the water the sky appeared to melt into the sea. We floated in an almost dreamlike state of motionless silence, broken only by the appearance of a number of dolphins which lingered close by.

Later, during dinner the phone rang - always a slightly unnerving experience on the high seas. It was the bridge telling of a large whale

Discovery's Signalling wickerwork

off the starboard side. I left my blueberry cheese-cake and rushed to the port hole in time to see the mammal surface and blow twice. We spent the evening on the bridge whale watching. A number of fin whales passed by in the opposite direction. The captain took the helm and we altered course to investigate a disturbance on the surface. It was a large sperm whale and we were able to observe it for several minutes. It dived when we got too close.

That moment alone made the trip worthwhile.

On the bridge that evening I took down the Radio 4 Shipping Forecast for the first time on the voyage.

The BBC's regular broadcast of the Shipping Forecast has been a necessary thing for mariners for decades, but technology is rendering it less vital. Today, commercial shipping is likely to receive the forecast by NAVTEX, a telex service which transmits safety messages and traffic news for ships. The NAVTEX equipment is tuned to a fixed radio frequency and is on continuously.

Messages are received automatically and printed onto a roll of paper, like a till roll. Using a radio fax machine, weather charts can also be received.

It is strange that so much is invested in the broadcast of the forecast. That's perhaps why I was out there. Years of listening to the magical names which seem to roll so effortlessly off the announcer's tongue made me want to know more. Physically visiting the named places is a privilege. So many can only visit in their minds, via a map or, occasionally, one or two of the places while on holiday.

I could be there in person. I could switch on the radio and, as the place came up, I could smugly look out and see whether the forecast might be correct. The radio broadcast was part of my journey. Strange to think that those who most needed it every day were getting their Shipping Forecast via a different route.

I bet they listen to it on the radio at home, though. Just, like me, to see...

TRAFALGAR

A forecast for Trafalgar is only broadcast on BBC Radio 4 during the 48 minutes past midnight bulletin, otherwise it is mentioned only in gale warnings. Its western boundary is the 15° west line of longitude, the same as Bailey, Rockall, Shannon, Sole and FitzRoy. To the east it covers the coastline of Portugal and Spain from Oporto to Cape Trafalgar.

Trafalgar for most people is a battle. Nelson and all that; Great Britain, great sea nation.

Where most countries celebrate success, however, we tend to celebrate failure and misfortune. On 5 November we celebrate the fact that Guy Fawkes failed to blow up Parliament. On Trafalgar Day we celebrate the death of our most famous Admiral. At least at the moment he died during that fateful afternoon the enemy surrendered.

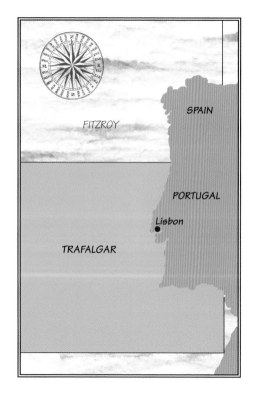

Poor Lord Nelson, he suffered from seasickness. I suppose that at least we can be thankful that his final voyage home, as a cadaver preserved in a cask of brandy, was peaceful.

Sea sickness is an awful affliction – and, unless you are already dead, alcohol is best avoided if you suffer.

I have two recommendations for the prevention of sea sickness. I'm sorry to say, however, that on the occasion we crossed Nelson's battleground they did not work too well.

Of course succumbing to the situation, voiding the tanks as it were, can be a solution in itself if the upheaval seems survivable at the time. Still, to avoid that try my first recommendation: Keep the horizon in view at all times. Your eyes transmit to your stomach all the relevant data needed for keeping its contents on an even keel. The second

Trafalgar
Southeasterly veering northeasterly 3 or 4 occasionally variable in southeast.
Mainly fair.
Moderate or good.

recommendation is to eat lots of McVities ginger nuts. They soak up surplus liquid and set like concrete, thus suppressing the discomfort caused by excess movement.

A combination of the two, together with the prescribed amount of the miracle drug Stugeron, had previously enabled me to survive Ullapool to Stornoway in a force 7 near gale.

Anyway, during the period that we sailed through sea area Trafalgar I did find enough calm for sketching. One whole day was spent on the 'monkey island', that is the name for the small platform on the roof of the bridge, the highest part of the ship. Although very windy, it is a good place to work, with a fine view across the rear deck. My sketch, the largest I can recall completing, was started in pencil, coloured with crayon and then redrawn over the pencil in ink.

That evening I painted the second of two magnificent sunsets which were one of the

Rear deck of Discovery

highlights of our journey. While I was working on the sunset painting back home in the studio, I found a magazine article about Turner's famous painting *The 'Fighting Temeraire' tugged to her last berth to be broken up*. This is as much a study of the sun setting over water as of the ship itself. Her finest hour was at the battle of Trafalgar and I was led to think about the line of painters who have worked as I have.

We may travel in different ways, have worked in different styles and be very different in temperament, but we all try to capture the essence of what we see.

Spending all this time aboard ship gave me time to read around the subject. I was surprised to learn how few of the words commonly used at sea or in relation to sailing are of English origin. In the countryside nearly all the words that relate to agriculture or the land have their roots in English. Go down to the coast or to sea and suddenly many of the words connected with things nautical are from other languages.

Cod, haddock, prawn, beach, jib, berth and capsize can all be traced back to our own language, but it would seem little else can. Inevitably the Vikings gave us many nautical terms; keel, raft, tug, windlass, wake, billow. Their aggressive excursions were followed by the traders of the Hanseatic League and then the powerful Dutch navies from where we assimilated a whole 'raft' of words; skipper, mate, buoy, deck, yacht, sloop, lugger, splice, commodore, and so the list goes on, seemingly endless. Spain, too, has been a rich source of words; flotilla, stevedore, cargo and embargo.

Most fascinating for me was the discovery of just how much the language of the sea and sailing has become part of our everyday speech, particularly from what one might call 'jackspeak', the language and terminology used aboard ship in Nelson's day.

We will say that we are sailing close to the wind, when our ship comes in we can let the cat out of the bag and celebrate with some 'down the hatch'. We might be learning the ropes, or taken aback, we will describe something as being a mainstay or it is packed to the gunwales, all ship shape and Bristol fashion.

These are some of the more recognisable terms. Others are less obviously nautical in their origin.

Rigging ropes passed through wooden blocks which were hauled up the rope to shorten and tighten it, pulley-like. Occasionally, where there were many ropes close together the blocks would become jammed, preventing any further tightening, this was known as being chock-a-block. If the ropes were slackened the blocks could be freed up allowing normal operation to be resumed, this action was called overhauling.

Sailing through sea area Trafalgar while learning all this made me feel that I, too, had sailed with Nelson.

FitzRoy

Sea Area FitzRoy takes its name from Captain, later Vice Admiral Robert FitzRoy who was made the first head of the Meteorological Department of the Board of Trade when it was created in 1854. The good gentleman introduced the first British storm warning service for shipping in 1861 and is credited with coining the word *forecast*. He achieved lasting fame in February 2002 when a Shipping Forecast area name change from sea area Finisterre came into force.

The more familiar former name, after Cape Finisterre in the northwest corner of Spain, continues to be used by the French and Spanish equivalents of the Shipping Forecast for the southern part of FitzRoy (the northern half being Pazenn). But then we never really did get on with the French and the Spanish when it comes to matters of the sea.

Considering that the Shipping Forecast is such an institution, so much part of the life of the BBC listener, this unthinkable happening took place nearly six years on from my voyage on *Discovery* and three years after publication of the first edition of this book. I feel now almost as if I am rewriting history.

In a break with Shipping Forecast tradition a sea area has been named (renamed in this case) after a person rather than a location, unless you count Viking as personal that is, but even that comes from the Old Norse word *vik* meaning a creek (where they lived).

Anyway, the good ship *Discovery* entered Finisterre, as it then was, on my fourth day aboard. During the day I found myself spending a lot of time on the bridge, where it was comforting

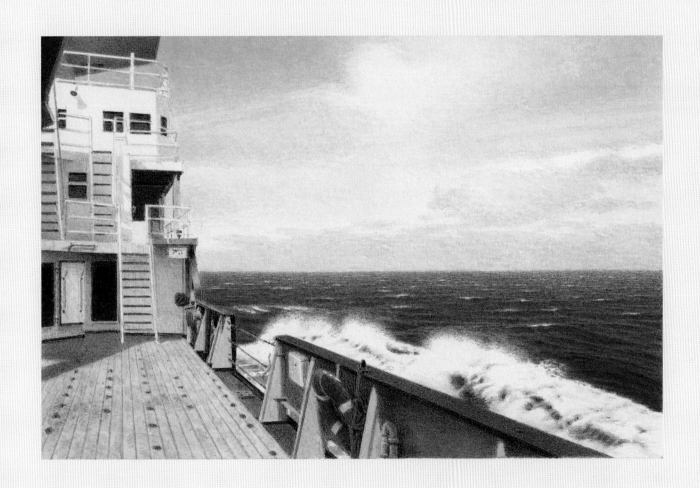

Finisterre
Variable 3 or 4.
Fair.
Moderate or good with fog patches.

to see that, with all the technological advances, our position was still marked hourly with a cross on a pencil line drawn across a paper chart.

Here was the only place to monitor what was going on around us. In the north Atlantic you do not come across signs saying 'Wolf Rock Lighthouse 354 km' or 'Finisterre/FitzRoy welcomes careful mariners'. There are no landmarks. Other vessels that may be out there are usually only visible on radar screens. We saw more dolphins than ships.

Dolphins are the most lovely of creatures. They attract one to the side of the ship whenever and no matter how often they appear. Even the most seasoned shiphands seem to take the trouble to look. Often skimming below the surface of the water, and appearing to be too close for their own good, they are definitely bringers of joy. It really is no surprise to me that so-called dolphin therapy has taken off in a big way. Lives have been transformed in therapy pools with these wonderful animals and I felt quite moved whenever they came alongside. To see them leap out of water is a very special experience.

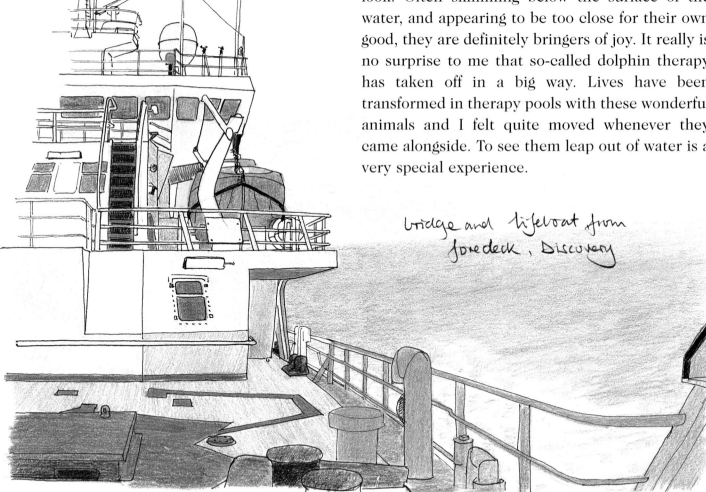

bridge and lifeboat from foredeck, Discovery

It was out here that I realised how important it is to me to know exactly where I am. I found that the presence of the dolphins helped give me a sense of place. Later as we passed Cape Finisterre itself we were too far away actually to see the land other than on the radar. Our escort of lesser black backed gulls were the most tangible sign that we were near dry land.

I had resolved to keep a more detailed diary than usual, imagining that one day surrounded by sea would feel very much like another. Reading back through the entries for my time in Finisterre I notice an entry made almost as an aside:

Noises in my cabin .

My cabin is lined with decorative interlocking steel panels, there is a laminated door in a steel frame, a suspended ceiling hiding all the pipework and ducting that runs between the decks, a wooden desk and wardrobe and an air-conditioning system which vents through the ceiling just above the washbasin. All these things make noises. They are caused by the motion of the ship or the reverberation of the various bits of machinery. With the motion of the ship the door and frame and the metal panels creak, the combination of motion and reverb makes the ceiling rattle and it sounds like a couple of mice running around up there. In a good swell my clothes swing around on their hangers and knock against the sides of the wardrobe and pencils roll across the desk. Above my head,

when I'm lying on my bunk (as I am now) something sounds like a radio which is turned on but not tuned in. The slight rumble of the ship's engines combine with the motor in the air-conditioning unit to sound like Concorde going over outside.

Ah, the silence of the sea!

In between my visits to the bridge I spent time on the fore and starboard decks sketching and painting. This was an unaccustomed luxury and something of a challenge for me. My usual work pattern involves spending part of the day in such activities, but much more time seems to be spent travelling in search of a good location. Being confined to the decks of the ship presented more of a compositional challenge with its limited number of views, but the opportunity to spend all day on nothing but painting without any of the concerns of everyday life was bliss. Even when spending a complete day in my studio I have to consider occasionally the possibility of helping out at least with the washing up.

Here on the *RRS Discovery* I was able to devote all of my time to the task in hand. Painting waves may seem an odd thing to do, but it certainly allows one to get to know the sea's many moods.

I was particularly pleased with a sketch which showed the most Art Deco-esque part of the vessel which included a view of the starboard deck. Back in the studio – with all of the usual interruptions – I worked it up into my Finisterre painting.

SOLE

Fog at sea is the strangest experience. On land it can simply be a matter of fewer visible landmarks. At sea landmarks are in short supply – often there is only one, the horizon.

On my sixth day aboard *Discovery* we encountered fog; 'Sole, variable 3 or 4, fair, moderate with fog patches.' And didn't we know it! Seeing another ship had been a rare event. Today seeing one end of the ship from the other could be, too. We were covered in a cool grey shroud. At times the sun made a brief appearance, visible as a light disc and dull enough to be looked at with the naked eye. Sometimes it was accompanied by a hint of blue. I celebrated one of these apparitions with a painting, thus confirming the crews' suspicion that artists are a touch eccentric.

'He's painting the fog!'
'Surely not.'
'He is, you know.'
'I don't believe it.'

I visited the bridge to take down the latest Shipping Forecast. Concerned faces studied the radar screens. They were ship watching. There were quite a few vessels in our vicinity and occasionally we altered course to keep out of their way. Some were probably small local French fishing boats. There was a vessel ahead on virtually the same course as us at six miles distance which is quite close for this amount of traffic in these conditions. The radar not only shows the positions of other craft within a set range (six nautical miles, 12 miles, 24 miles etc.) but after a few sweeps is also able to show the course of other vessels, with their closing speed so to predict our nearest position as our courses cross.

Sole
Variable 3 or 4.
Fair.
Moderate with fog patches.

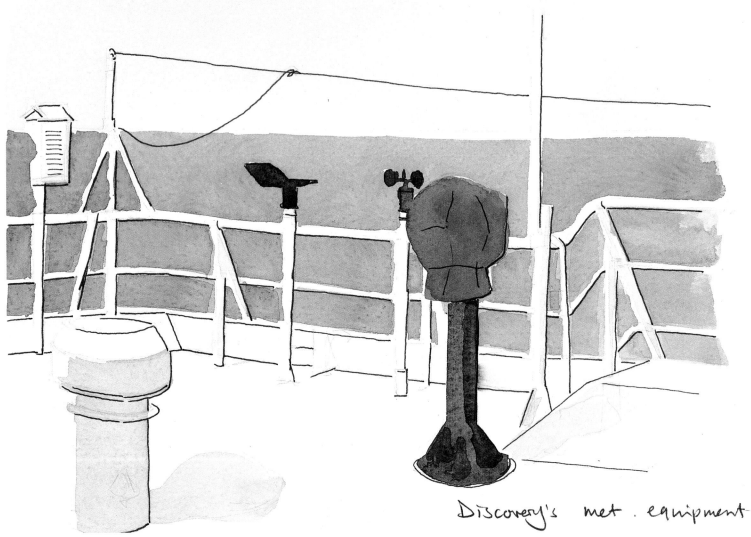

Discovery's met. equipment

At 10.45 am we picked up a mayday message in Morse code, which was then entered into the ship's log. A Belgian trawler had collided with a sport fishing vessel and there were people in the water. Others were left to deal with the situation, no doubt a rescue helicopter would be scrambled, all we could do was to let the Coastguards know that we were available.

Discovery is one of a select group of ships, numbering 300 or so, which make meteorological readings for the Met. Office. This is only undertaken if it is at sea in or near our Shipping Forecast sea areas. The readings are made every six hours by the officer on duty on the bridge, who will have been on a meteorological course as part of the officer training programme.

Most of the ship's meteorological equipment is located on the monkey island on the roof of the bridge, with the data being transferred electronically to the bridge where it is constantly displayed. The amount of information required by the Met. Office is extensive, and includes the ship's call sign and position and the time the readings were made. The readings have to be taken over as short a time as possible in order to give the Met. Office a 'snapshot' of the conditions at the given time.

The weather at present and in the recent past, visibility, wind speed and direction, air and sea temperatures, pressure including its tendency (falling rapidly, rising more slowly etc.), cloud type and cover at low, medium and high levels, including the height of the lowest cloud and cover estimated in eighths, icing both on the ship and in the water if applicable, are all recorded. The state of the sea, including the wind-blown waves and the swell waves are estimated as to their height, frequency and direction.

The information gathered is, by the nature of the weather, often difficult to quantify precisely, especially factors like the wind and waves. Consequently it is usually described as being within a certain range of values. Each of these values or ranges of values is allocated a number, and so is the type of information which is being referred to, such as pressure tendency or medium level cloud type. All this data is entered into a log book. The ship's radio officer will enter the set of numbers representing the readings into a computer and transmit the data to the Met. Office via satellite.

The fog became more patchy as the day progressed. We passed from bright, blue, sunny clearings through a fuzzy white wall back into the damp greyness. During the sunnier spells it became quite pleasant out on deck so I clambered up to the monkey island, where it was less windy than on my previous visits, and sketched some of the meteorological equipment.

At 3.30 pm a sunlit Wolf Rock lighthouse was clearly visible at a distance of three and a half nautical miles off the starboard side. A watercolour sketch marks another first on this voyage – my first painting whilst viewing the subject through binoculars.

As sea areas go Sole is one of the few not to be joined to a bit of coastline. It is just a block of sea. Together with Bailey, Dogger, Fisher, Forties and Viking, Sole is named after a sandbank. There is nothing visible, the name just exists on navigation charts as the Little Sole Bank and the Great Sole Bank, areas of significantly shallow water.

LUNDY

It seems to me that the body of water between the south coasts of Pembrokeshire, Glamorgan and Monmouthshire and the north coasts of Cornwall, Devon and Somerset should have a more appropriate name than the Bristol Channel. It's more than a channel, and estuary, too, is far from adequate. The narrow end is already known, quite rightly, as the Severn Estuary. I am sure that South Wales must feel pretty hard done by.

On some old maps, in the days before reliable navigational instruments, when mariners intending to sail up the English Channel found themselves on the wrong side of Cornwall, it is referred to as The Wrong Channel. On the beaches of the Gower Peninsular or Woolacombe it certainly looks, and feels like, the real thing; the sea. So how about a

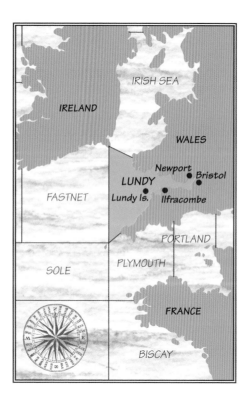

campaign in support of The Lundy Sea?

All along the north and south coasts people proudly proclaim that their bay, harbour, point, cove, bridge, has the second highest tidal range in the world. At well over 12 m this is second only to the Bay of Fundy between New Brunswick and Nova Scotia in Canada.

One of the best places to witness this drama is at the town bridge in Newport, where the considerable flow of the River Usk is sucked out of its channel by the ebb tide, as if someone has pulled the plug out, reducing it to a comparative dribble.

Take a summer evening walk round the headland at Baggy Point and you can watch the sun set behind Lundy Island, It is difficult to believe that from here it is 27 km away. Lying at about the point where the Lundy Sea meets the

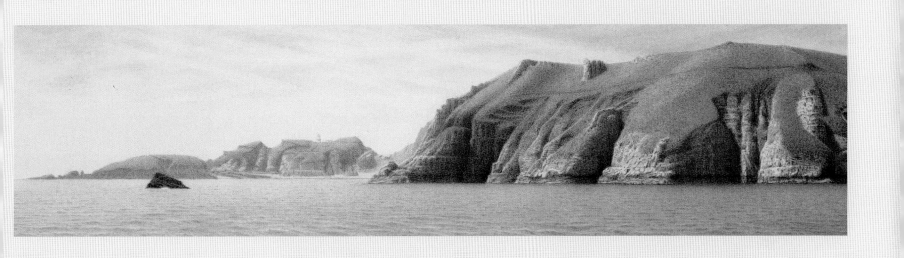

Lundy
Northeasterly or variable 3 becoming southerly 4.
Fair.
Good.

Atlantic Ocean, the island is made of granite which erupted from a volcano located under water a little to the north, at the same time as those on Skye, Mull and Arran. The name is old Norse for Puffin Island.

Nowhere else in Britain can you remain so close to normal everyday life yet feel so completely away from it all.

A natural fortress, the island is an undulating plateau 5 km long and nearly 1 km wide, a great hazard to shipping and consequently a ship graveyard with more than 200 recorded wrecks.

In 1987 it became Britain's first marine nature reserve. The wildlife both in and out of the water is outstanding. For many it is the main reason for their visit. Mountain goats, Soay sheep, Silka deer, grey seals, basking sharks, dolphins, many rare and unusual birds and, unique to the island, the Lundy cabbage all attract the visitor.

The landscape is open and virtually treeless so that consequently the few buildings, mostly clustered round the cliff top by the path leading up from Landing Bay, are prominent features. The church was built by the Reverend Hudson G. Heaven whose family owned Lundy for much of the nineteenth century, when the island became known as the Kingdom of Heaven. On the other side of the island, but only a short walk away,

passage to Lundy

stands the original lighthouse. Built in 1820 on the highest point, at the expense of a group of Bristol merchants, the light proved less than satisfactory. Unusually it displayed a secondary light lower down the tower to help mariners distinguish it from other lights in the vicinity. However, from a distance the lights appeared to merge into one, and the tower was so tall that the top light was sometimes obscured by fog. In the 1890s low level lighthouses were built at the north and south ends of the island.

Since 1969 Lundy has belonged to the National Trust. It is managed and maintained, however, by the Landmark Trust, which has restored many of the buildings for renting out, short term, to those who want somewhere unusual or remote to stay. Lundy is both. The island is reached by a boat, the *MS Oldenburg*, which sails several times a week from either Ilfracombe or Bideford, depending on tides. The journey of about 36 km takes two and a quarter hours and offers good views of the North Devon coast.

Landing on Lundy is an adventure in itself. There is no quay. The *Oldenburg* enters Landing Bay and is met by a small open launch. Passengers transfer to the launch in groups and are then ferried to a tractor-drawn platform positioned at the water's edge. This is then followed by a 'gentle stroll' up the 120 m cliffs. Thankfully the Marisco Tavern is at the top.

On the day that I went out, the sea in Landing Bay was not yet deep enough for the Oldenburg–launch–platform arrangement to work, and we were taken on a cruise along Lundy's east coast, the gentler side, to view a seal colony. This proved to be fortuitous. Visibility was good, if only slightly hazy, and the sun was in just the right position to bring out the best in the cliffs; a gift I could not refuse.

FASTNET

astnet has strong associations with ocean going vessels of all sizes and from all ages, being most closely identified with the biennial Cowes to Plymouth yacht race via the lighthouse rock.

Cobh (pronounced cove), the port of Cork, is the home of the world's first yacht club, The Royal Cork Yacht Club founded in 1720, and was for many years connected with Atlantic crossings. It was the port of departure for emigrant ships in the nineteenth century and the starting point for the very first transatlantic crossing by the steamship *Sirius* in 1838. In the days of the luxury liners it was the first or last stop on the Atlantic voyage and so was the last port of call for the ill-fated *Titanic*.

My first view of the famous rock lighthouse came on a day when just about every sea area had

a gale warning, except for Fastnet. In Toormore Bay near the village of Goleen two local fishing boats were pair trawling in comparatively calm water, in the lee of Mizen Head. These were the sight that first caught my eye.

Through binoculars Fastnet lighthouse was clearly visible, the horizon not as flat as it had appeared with the naked eye. A churning sea crashed against rocks close to the lighthouse showering spray over the tower. When the weather is really bad, Fastnet Rock is one of the best places to enjoy it and be in awe of the sea's power. The lighthouse, Ireland's most southerly point, lies exposed to south-westers and is frequently swept by big seas that sometimes clear the lantern, 45 m above normal sea level, making the tower sway as much as 30 cm from the vertical. It is no surprise that the water the

Fastnet
South or southwesterly veering westerly 5 to 7.
Showers.
Moderate or good.

Roaringwater Bay

landward side of the lighthouse is called Roaringwater Bay.

Between Fastnet Rock and the mainland is Cape Clear island, which in the nineteenth century was the terminal of the Atlantic Telegraph Cable. Messages put into floating containers and thrown overboard from transatlantic ships arriving from America would be collected by local boats and taken ashore for transmission to London. News of the progress of the American Civil War reached Britain this way.

On the western side of Roaringwater Bay is the small village of Crookhaven where there are two further historical links with America.

The first is a chapel dedicated to St. Brendan the Navigator, who is said to have sailed from Crookhaven in the sixth century to discover America. His epic voyage was undertaken in a cowhide coracle crewed by monks. They apparently encountered many miracles on the journey, including a whale that docked beside them at Easter so that they could step onto its

back to celebrate mass. St. Brendan described many features from his landfalls in America, although I understand they all bear a remarkable similarity to places around Galway Bay.

Close by the chapel is Marconi House B&B, where in 1902 Guglielmo Marconi erected a mast and sent his first radio message to America.

From Crookhaven the road passes behind the magnificent sandy expanse of Barley Cove to Mizen Head, the most southerly point of mainland Ireland, which as such is a popular site for visitors. The effect of the Gulf Stream and the proximity of the continental shelf make Mizen Head one of the best places in Europe for whale watching.

The end of the headland is in fact Cloghane Island, although it does not appear to be detached from the mainland as one approaches it from the car park. The sea has exploited a weakness in the rock and cut a sheer gorge through the headland, which was spanned in 1910 by an unusual suspension bridge, 52 m long and 45 m above the sea, an early example of reinforced concrete. The path across the bridge leads to Mizen Head Fog Signal Station, which operated in conjunction with the Fastnet lighthouse. In poor visibility the keepers would manually set off explosive charges at three minute intervals. The signal was discontinued in the 1970s and the buildings are now a visitor centre, giving a flavour of the lives led by lighthouse keepers, and telling the story of the building of Fastnet lighthouse and of the Fastnet yacht race.

Mizen head was for me a good place to enjoy a force 7 wind. Waves crashed over the headland in a deluge of spray, and where they thundered against the cliffs below the footpath, the updraught caused large blobs of salty foam to be thrown into the air which then fell like the beginnings of a blizzard.

As I toured around, I found that one of the most striking features of the landscape was the technicolour bungalows, painted in vibrant colours I had not seen anywhere else. I asked an Irish friend who had worked in Skibbereen, on Roaringwater Bay about this phenomenon. He put it down to the Spanish influence, giving as evidence the fact that some of the women in the area still dress in black. South-west Ireland had trading links with Spain, Portugal, and possibly Phoenicia. There were also remnants of the Spanish Armada sailors who came ashore and settled in the area, and even of an Algerian invasion of the town of Baltimore in 1631. This apparently led to the establishment of nearby Skibbereen by Baltimore's Protestant English settlers.

My Irish friend also speculated on the possibility of a link with South America, suggesting that traders from there followed the eels as they drifted on the Gulf Stream, from their spawning grounds in the Sargasso Sea into Ireland's rivers. As evidence for this he offered Ireland's long association with the potato, which originally came from Peru.

IRISH SEA

The nature of the Shipping Forecast has necessitated the drawing of many straight boundary lines across a map to create divisions where nature has provided only one; that between land and sea, a coastline. Some sea areas are without a coastline altogether. Others like Biscay or Malin, for instance, have a considerable length of coast making up about 50 per cent of their boundary. Faeroes, a crisp parallelogram on the map, has 1,100 km of coastline.

Irish Sea is different, being the only sea area already there when the lines were drawn, entirely the product of Mother Nature plc. Ninety five per cent coastline, the man from the Met. Office was only required to delineate the 40 km of North Channel between Portpatrick and Larne, and the 80 km of St. George's Channel

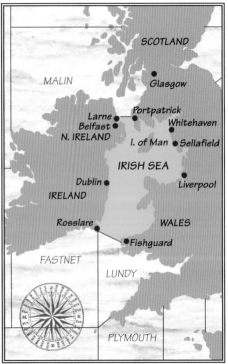

between Fishguard and Rosslare, where Irish Sea becomes Atlantic Ocean.

The Irish Sea has a reputation that no weather forecast is required because it is always stormy and a rough crossing is guaranteed. If that is the case the ferry to the Isle of Man would have been a good location from which to paint a typical storm-tossed day, lurching from one huge wave to the next, disappearing out of sight in the troughs. Fortunately I was unfortunate, the outward crossing from Heysham was bright and breezy and completed on an even keel. Maybe the return trip into Liverpool a few days later would be more typical. This too was comfortably calm, with the added disadvantage of fog.

One stormy period did come along during my visit, but of course as luck would have it I was on

Irish Sea
Southeasterly 5 or 6 occasionally 7 at first.
Rain or showers.
Moderate or good.

land at the time. Ah well, worse things happen at sea, and I needed to be out there painting it! My consolation was that the day ended with a most civilised fish supper at the quayside in Douglas.

The fog had spoilt my crossing to Liverpool. I had been looking forward to sailing up the Mersey in the wake of so many Belfast packets and graceful liners but there was very little to see. As we approached the quay the familiar shape of the Liver Building emerged from its foggy shroud. Its pale grey silhouette seemed to symbolise the decline of the port, all was eerily quiet. It hardly seemed possible that a century ago Liverpool's ships carried 40 per cent of the world's seaborne trade.

Failure to meet the changes in sea trade and a serious decline in shipbuilding has hit many Irish Sea towns and cities particularly hard, but I was surprised to learn of one example where this was not a recent occurrence. Whitehaven on the Cumbrian coast was, in the eighteenth century, Britain's third largest port, having cornered the market in handling the tobacco trade with the colonies in America. It had grown from a one boat fishing village into a deliberately planned gridiron town, the first in England since the Middle Ages. Decline was partly brought about by a decision not to build a deep water harbour to cope with the increasing size of cargo ships.

The trade moved to a developing Glasgow where a previously unnavigable upper Clyde was dredged specifically for this purpose. The later development of the coal and iron industries enabled Glasgow to prosper. As these industries were also available at Whitehaven the Cumbrian coast might have looked very different today. Maybe the Lake District had a lucky escape. I say that as a fan of Glasgow.

Just the weather for dark glasses

It was not so fortunate in its acquisition of the abomination that is the nuclear waste plant at Sellafield.

My third opportunity to paint Irish Sea came at the beginning of my tour round the coast of Ireland to see Fastnet, Shannon, Rockall, Valentia and Malin Head. This time I had decided to travel by Aer Lingus rather than Irish Ferries. Although not my reason for taking to wing, the thought had occurred to me that I could paint the sea from 9 km up, but alas I was thwarted by the weather again. A cloudy sky meant that between the south-west coast of Wales, and the approach to Dublin, I saw the sea for about four seconds.

Fourth time lucky and another encounter with the Vikings. Howth (rhymes with both) is a small town on a headland (for which the Viking word is hoaved) which is now joined with the eastern suburban sprawl of Dublin. The Howth Peninsula frames the north of Dublin Bay and the town clambers picturesquely over its 171 m high summit, from where I enjoyed the view across Dublin Bay to the hills of Wicklow beyond.

The harbour was constructed at the beginning of the nineteenth century as Dublin's port for the packet boats from England, but because of silting was eventually abandoned in favour of Dun Laoghaire just across the Bay. Today it is home to a small trawler fleet, and a good collection of 'fresh from the ship' seafood restaurants where I enjoyed some only very slightly rubbery squid washed down with a few glasses of Guinness.

The harbour is also home to, and few probably know this, an RNLI lifeboat. I had not realised this at first or, indeed, expected it. It seems strange to find a Royal charity working in the Republic. Still, when there's lives to be saved...

I was on the harbour wall watching some trawlers leave and studying the small offshore island of Ireland's Eye (Viking again; *Erin's Ey*), thinking that this would make a good painting for Irish Sea. Just as the last trawler was turning out of the harbour the lifeboat came into view, returning home after a 'shout'.

SHANNON

Taking the name of a river estuary for the sea area seems appropriate for Tyne, Humber and Thames as these rivers have, in the past if not now, all been great shipping gateways. The River Shannon, albeit the longest river in the British Isles, has been less significant in maritime terms. Its main port, Limerick is nearly 100 km from the sea, so there is no sense of being on the edge of the Atlantic Ocean. However, since the 1930s Shannon has been the beginning and end of transatlantic crossings.

On the south shore of the Shannon estuary, 60 km from the sea, is the village of Foynes. From 1939 until 1945 Foynes was at the centre of the aviation world, being the eastern terminus for transatlantic flights in the brief but grand career of

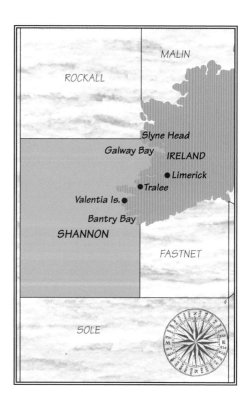

the flying boat; truly an air-port.

Pan Am and American Export Airlines flew from La Guardia, New York and Imperial Airways (later BOAC and British Airways) from Baltimore, via a refuelling stop at Botwood, Newfoundland, to land on the Shannon for refuelling again, before continuing across Europe. Imperial Airways' English terminus was Poole Harbour in Dorset. In winter, when Botwood could not be used the flying boats followed a southerly route via Bermuda, the Azores and Lisbon. The fare for a one way crossing was $337 – a staggering $4,500 in today's money.

For a more modest sum one can take a nostalgic flight back at the Foynes Flying Boat Museum, where there is the original terminal building. Film of it in its heyday is shown in a 1940s cinema.

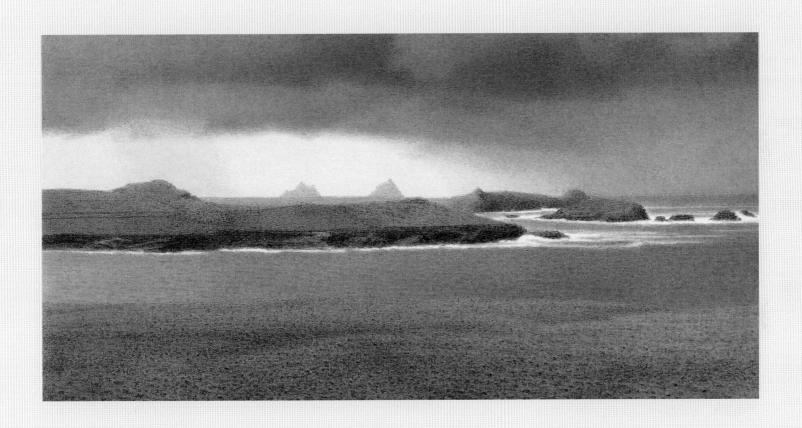

Shannon
Southwesterly 5 or 6.
Squally showers.
Good except in showers.

Another survivor from those days is Irish Coffee, concocted one cold night in 1942 by Foynes' chef to warm some damp, miserable passengers stranded by bad weather.

In 1945 the service was discontinued and a new Shannon airport built on land across the estuary, 16 km to the north-east, is still Ireland's terminus for transatlantic flights.

The sea area is a 300 km wide stretch of Atlantic Ocean with the edge of the continental shelf meandering down the centre and the Porcupine Bank in its north-west corner. The coastline stretches south from Slyne Head on the edge of the Connemara National Park, around Galway Bay, across the mouth of the Shannon and round the south-west corner of Ireland to the seaward end of Bantry Bay. It is more varied than any I have seen.

In the north the mountains of Connemara, picturesque in their austerity, are a backdrop to innumerable inlets and islets. On the south side of Galway Bay

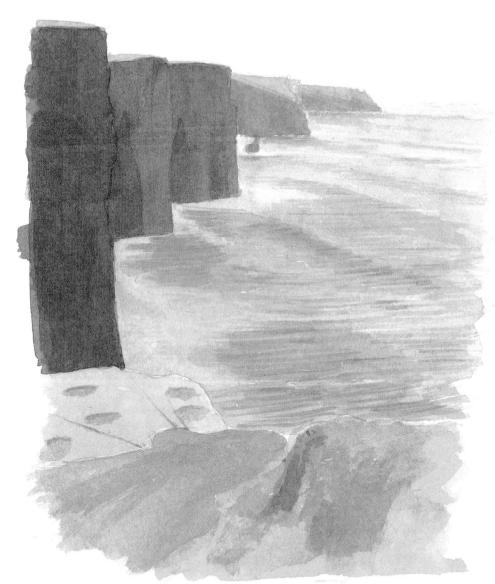

Cliffs of Moher

is The Burren, 250 km² of rock virtually devoid of water, soil or trees. It has the best limestone pavement to be seen anywhere and is a botanist's dream. Here Arctic, Alpine and Mediterranean plants coexist. I had not experienced anything quite like this before. It was unearthly, like one huge scarred piece of rock. My cousin John, who was with me on this trip and who had worked for many years in the Middle East, said it reminded him of Iran.

The Burren limestone continues submerged across Galway Bay making three offshore appearances as the Aran Islands, home of the multipatterned white sweater. Further south are the Cliffs of Moher, apparently innocent rolling downland when approached from inland. Green, gentle and inviting, just as the ground reaches its peak it is sliced away, presenting to the sea a dramatic fortress of strongly banded sandstone 8 km long and 230 m high. Their scale is difficult to take in.

Immediately south of the Shannon is a more gentle coast of dune-backed bays interspersed with high cliffs ending at Tralee, where the character of the coastline changes substantially. Linking the west and south coasts are three long mountainous peninsulas: Dingle, Iveragh and Beara, jutting out into the Atlantic and the most westerly land in Europe.

I found that the most surprising aspect of my visit was the size of this area. On a map of Ireland it is just the jagged bit in the bottom left corner, but driving round on the coastal roads seemed to take for ever, although that was partly due to the roads themselves, which were often little more than winding country lanes lined with fuchsia and gorse. The coast was rugged and bungalowed.

The views across the bays from one peninsula to another are superb, made dramatic by the weather. Heavy squally showers with bright interludes marked my time there. The most dramatic view of all was out to sea from the south coast of Valentia Island, the Skelligs. The Skelligs are a pair of jagged pyramidal crags 10 to 12 km offshore, one of which, Skellig Michael was the site of a monastic community from the seventh to the thirteenth century.

I had first encountered the Skelligs a few years ago at a small gallery in Portobello Road, in an aquatint by Norman Ackroyd, *the* etcher of wild landscapes. I had just returned from a trip to Skye and was still tuned in to rugged scenery. His image made a lasting impression on me, and was recalled when I noticed the Skelligs on the map as I navigated my way to Valentia Island – which I was visiting because it is one of the Shipping Forecast's coastal stations.

I had just crossed the bridge from the mainland, my mind focussed on finding a good location for the Valentia painting, when I looked up from the map to get my bearings and there they were. It was like one of those occasions when you turn round, not expecting someone to be there; shock, shriek, sharp intake of breath, 'stop the car *now*!'

ROCKALL

I heard someone on a BBC natural history programme once say that Rockall is the remains of an extinct volcano and was once part of Greenland. There can be no disputing that its origin is volcanic, but Greenland? I find that hard to believe. But then tiny and isolated Rockall has always been surrounded by a sea of uncertainty.

There is a Celtic legend which says that it is the last remnant of the western land of eternal youth, Brasil, which became submerged by the Atlantic. There is certainly more to Rockall than the granite lump which projects above the waves.

Its position was not accurately obtained until 1831. Within a 30 km radius a conventional compass will cease to be of much use because the rock is highly magnetic. On Admiralty charts a

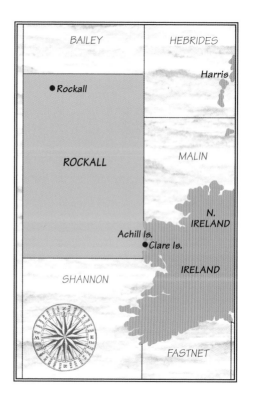

200 m contour, also used to mark the edge of the continental shelf, encircles Rockall enclosing an area large enough to contain all the islands of the Outer Hebrides which in shape is a mirror image of them. Separating them is 400 km of the north Atlantic and the Rockall Trough, in places over 2 km deep.

My search for who is actually responsible for Rockall eventually led me, much to my surprise, to the Western Isles Council in Stornoway. I had interesting and varied conversations with representatives from various departments; Corporate Support, Communications, Economic Development, even the Stornoway Harbour Master. All were well informed and very helpful but the whole thing seemed a little bizarre, after all it's just a piece of rock stuck out in the Atlantic isn't it?

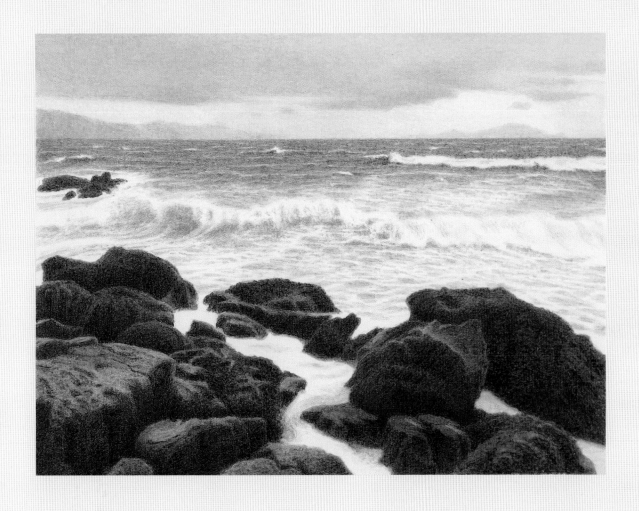

Rockall
Southerly 4 backing southeasterly then increasing 6 to gale 8 perhaps gale 9.
Showers then rain.
Good becoming moderate.

As far as they are concerned Rockall falls within the electoral ward of Obbe, part of South Harris. In theory they would be responsible for giving planning permission should anyone want to build a permanent structure, and for collecting the council tax from the theoretical inhabitants. I would be interested to know how this would be calculated. For instance, I cannot imagine a refuse truck making the 800 km round trip every week to empty the bins.

Measuring a mere 25 m in diameter and rising just 19 m above the sea, Rockall's political significance goes way beyond its apparent diminutive stature. Ownership is disputed. The current contestants are Britain and Ireland, although Iceland and Denmark have also laid claim to the rock in the past. In the days before territorial waters were determined by the EU, claiming Rockall for Britain was a huge advantage to our North Atlantic fishing fleet and Britain's claim was staked in the way we do best.

On 18 April 1955 a party of Royal Marines from

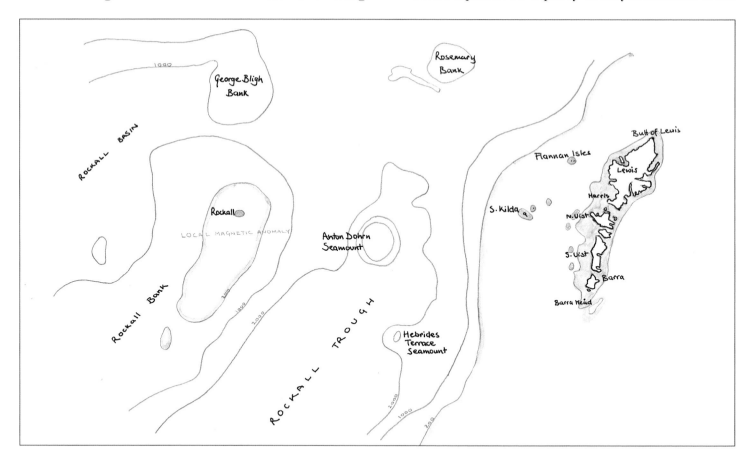

HM Surveying Ship *Vidal* landed by helicopter and raised the union flag declaring possession in the name of Her Majesty the Queen.

The 1982 Law of the Sea Convention states that waters surrounding islands are the property of the controlling nation. However if the land is deemed uninhabitable and economically non-practicable, the land is defined as a rock and no control of nearby waters exists. Not surprisingly Britain is not a signatory to this law.

Now that oil and gas exploration has begun in the vicinity, ownership becomes even more crucial.

Rockall's remote position, only just within the sea area bearing its name, makes it difficult to visit. However it is possible to reach another, much larger island also within Rockall sea area, which allowed me the satisfaction of knowing that at least I could leave the mainland to visit somewhere offshore in sea area Rockall.

Achill is the Republic of Ireland's largest island, lying off the west coast of Co. Mayo. It is isolated, but accessible, making it a destination for those Irish wanting a 'get away from it all' holiday. I was there in the latter half of a wet November, when I found its charms a little difficult to unearth. Nevertheless, there I was on an island in the Atlantic in sea area Rockall, and this without having to forgo the comfort of my car.

With a 125 km coastline enclosing three mountains and large areas of peat bog, the Achill landscape is more varied than Rockall's. The south and east coasts are hilly but gentle, the north and west more mountainous and craggy.

The Shipping Forecast gave the possibility of gales, and I wanted to encounter the sea at its wildest so took the Atlantic coast drive, in both directions. This narrow winding route, along the entire west coast, has some superb views of the wild rocky shore and its dramatic cliffs.

Coastal communities on Achill are scattered, with more abandoned properties than I had encountered anywhere previously. It is a good place to come to be at one with nature at its most austere, but not to work.

The last kilometre of the drive to the western tip of the island, Achill Head, is along a narrow track, a mere ledge around the mountain Croaghaun, with a near vertical rock wall to the right, rising to a dizzy 668 m, and a vertigo induc-ing drop into the sea on the left – not the best place to get a puncture or run out of petrol. At the end relief came in the form of a car park over-looking a small bay.

As the weather worsened, I clambered over the rocks at the eastern end of the bay and sketched the waves with the wind increasing and Clare island beginning to disappear from the southern horizon.

MALIN

Had the Shipping Forecast been in existence 400 years ago more ships from the Spanish Armada would probably have survived their enforced detour around the treacherous waters off the north British coast. Caught out by dangerous rocks and bad weather many were lost and their whereabouts will never be identified. Some wrecks were well recorded at the time and Malin seems to have more than its fair share. Lured by tales of lost treasure, people still search in hope of a bonanza.

Probably the most famous wreck is that of a galleon claimed by legend to be either *Almirante di Florencia* or the *San Francisco*, the ship carrying the Armada's pay chests. Blown up either by accident or design while anchored in Tobermory Bay, the vessel is lying just 300 m off the pier, but nothing of note has ever been recovered.

More accessible treasure might be found at Streedagh Strand in Co. Sligo. Three frigates anchored for four days off the island of Inishmurray in Donegal Bay waiting for a storm to abate. On the fifth day the wind increased and they were driven onto the long sandy beach at nearby Streedagh. Within an hour all three ships had been pounded to pieces and although some crewmen survived, the next day 1,100 bodies were said to have been washed ashore. Nothing of the ships exists, but here, too, is thought to be a quantity of gold coins buried in the sands of the beach – so do not forget to take a bucket and spade.

If I had to make the decision to live and work in one sea area with a mainland coastline, for the sake of variety both natural and social I think it

Malin
Westerly or northwesterly 5 or 6.
Showers.
Mainly good.

Tobermory Harbour

would have to be Malin. Malin has just about everything, apart from a warm dry climate.

Coastlines here are as varied as they could possibly be. In the south are the dramatic cliffs of the Slieve League Peninsula on the north side of Donegal Bay, and in north Antrim, the strange and wonderful Giant's Causeway. To the east, the sea meets the Scottish Highlands in a labyrinth of lochs with bustling Oban at the entrance to the Great Glen, and industrial Firth of Clyde with its playground, the Ayrshire coast, all sandy bays, links golf, jolly resorts and regattas 'doon the watter'.

For me, however, what makes Malin so special is that with all this there is also the splendour of the islands. Whether seen from the mainland, from one another or – best of all – as ever changing views given from a moving vessel, they are endlessly captivating.

Some of the best journeys for enjoying the mainland and the islands together are by ferry from Oban. To the south, the ferry to Kennacraig on the north-west side of the Kintyre peninsula first sails down the Firth of Lorn for 60 km to the small island of Colonsay, linked at low tide to its even smaller neighbour Oronsay. From there it

crosses to the large islands of Islay and Jura, separated only by the narrow channel leading through to Kintyre across the sound of Jura.

Islay has a relatively large population, gainfully employed in its eight distilleries. The Islay peat, soaked by the salty Atlantic mists and burned to dry the malt, gives the island's whisky a distinctive hint of the sea, a lobster's nip. By contrast Jura (from the Viking; yes, them again, *Dyr Oe* – Deer Island) is almost uninhabited, a wilderness of moorland crowned by its three distinctive conical peaks, the Paps, visible from almost anywhere in the eastern half of Malin.

My favourite journey from Oban is to the north-west along the Sound of Mull. This can be enjoyed on the short trip to the pretty port of Tobermory, Mull's capital, en route to Barra, the nearest of the Western Isles where the film *Whisky Galore* was shot, or to the small islands of Coll and Tiree beyond Mull.

One journey on this latter route was particularly memorable. The ferry left Oban in a cool, damp and cloudy early June dawn. Crossing the entrance to Loch Linnhe revealed a breathtaking view of the still snow-capped peaks of Glen Coe and Ben Nevis away to the north-east. As we proceeded along the Sound of Mull the higher, thinner clouds were illuminated bright peach and gold by the rising sun. The hills and mountains on both sides were capped by lower cloud of as many subtle shades of grey as one could imagine; from pink through lilac to blue, an ever changing meteorological kaleidoscope. Such splendour; and before breakfast, too.

The next day the return journey was made in quite different conditions. The wind had turned around and was blowing briskly from the opposite direction, the north-west. The sky was mostly blue and the air so clear that after leaving Coll not only were the islands of Muck, Eigg and Rhum clearly visible, but beyond them the faint silhouette of Skye could be seen 65 km away, enabling two ranges of Cullin Mountains to be enjoyed in view.

As we turned into the Sound of Mull the grandeur of Mull's mountains unfurled off the starboard side. Shortly after, the sky darkened and the temperature dropped suddenly as an exceptionally heavy hail storm passed over the ferry. It, too, was heading for Oban. A relaxing Saturday lunchtime watching the world sail by became a frantic period of activity as I recorded the storm engulfing the mountains.

HEBRIDES

ape Wrath seems such an apt name, conjuring up pictures of battered headlands and angry seas, and so, quite often, it is. The name however is thought to derive from the Norse word *hvarf* meaning a turning point. After sailing west along the coast of their southern land, Sutherland, It is here the Vikings would have turned south into the sea of the *Sudreyjar*, the Southern Islands. To the Romans they were *Ebudae*. To the Met. Office it is only those islands north of the 57° N line of latitude, that is, St. Kilda, the Western Isles without Barra, Skye with its clutch of Scalpay, Raasay, Ronay, Pabay and Soay, Canna with the top half of Rhum and the mainland west coast as far south as Mallaig.

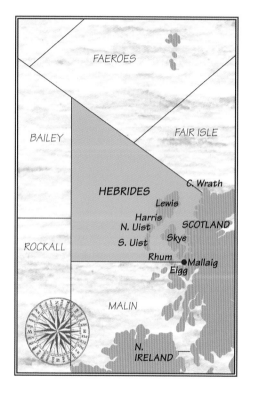

If outstanding natural beauty could be converted directly into a financial resource the economic map of Britain would be turned upside down. Instead, the magnificent isles that have the power to produce a lifetime of dreams from a single visit make up some of the country's most uneconomic landscape, impoverished, depopulated, bewitching.

If you want an unsentimental but compassionate account of the grim slog of everyday life here read Derek Cooper's superb book *Hebridean Connection*. If you have never been, visit Skye in the autumn, it will burn a hole in your heart until the next visit and bring tears to your eyes every time you think about it. Take an oxygen supply, it's that breathtaking.

For the old romantics who still want to sail over the sea to Skye and those of us who cannot bring

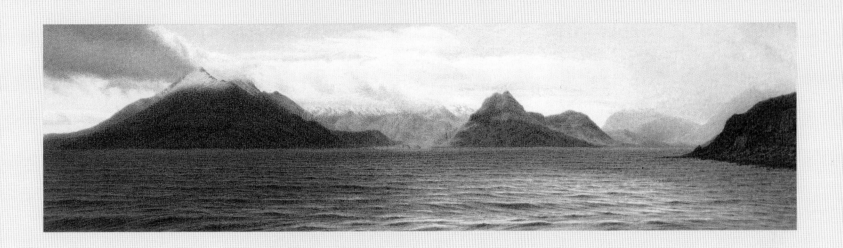

Hebrides
Northerly 6 to gale 8.
Showers.
Good.

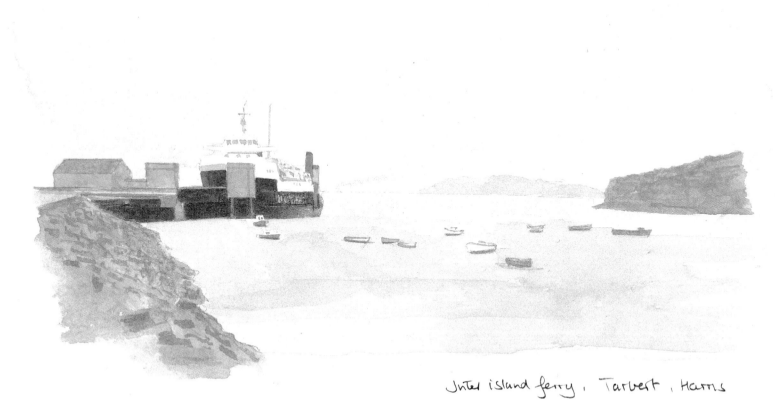

Inter island ferry, Tarbert, Harris

ourselves to use that ghastly bridge, those wonderful folk at Caledonian MacBrayne still operate a car ferry from Mallaig to Armadale. Portree is a good base from which to tour Skye. It is a nice place to return to at the end of a day out, with plenty of choice for sampling the local food. Passing a fish and chip shop by the harbour I noticed that in the window they had a live piranha in a tank. On it was a label which read *Janet*.

Changeable is the word most often used to describe the British weather. For the Hebrides it seems somewhat inadequate, capricious or volatile would be more appropriate.

When it is cold and dull and the drizzle is penetrating, when visibility is down to less than 1.5 km and the colour has drained out of a landscape devoid of detail, be thankful it isn't windy. When it is windy and you are on land, find a rocky shore and enjoy the drama. When it is windy and you are on a ferry crossing the Minch, put on as many layers as your legs will carry, stand on deck gripping something that is welded to the rest of the ship and enjoy the excitement, but be careful not to stand downwind of anyone with green cheeks.

The areas of low pressure, which endlessly scud across the top of the national weather maps on television often produce unsettled periods, while most of England will be enjoying a calm spell. The

surprise is that everything seems to happen so quickly. A day of sunshine and showers can produce half a dozen periods of each, which occur with great intensity. Half an hour of bright clear sunshine, then suddenly comes a brolly-piercing shower lasting about fifteen minutes and then back comes the sunshine.

In one afternoon on Skye I saw rainbows, some of them doubles, on six separate occasions. Watching all this happen as one looks out across the Little Minch is one of the most rewarding aspects of a visit. A showery evening at Neist Point on Skye, watching the sun set through showers over the mountains of South Uist is out of this world. The drama of the Skye Cullins can be enjoyed from almost anywhere on the east coast of the Western Isles but where they are closest, from South Uist, the coast is, sadly, less accessible. On such a day a very fortunate traveller will be crossing the Minch on one of the ferries which link the outer isles with each other, with Skye and with the mainland, witnessing the spectacle with a 360° view.

On the day of the rainbows I had visited Elgol for the first time, not knowing what to expect, but from studying the Ordnance Survey map, anticipating a good view. The drive from Broadford round the southern edge of the Red Cullins presented some superb scenery, especially along the southern shore of Loch Slapin, from where the craggy eastern side of the Black Cullins looked especially menacing. Driving down the last few hundred metres into Elgol, the islands of Rhum and Eigg became visible on the south western horizon.

From the car park I walked down to the shore, where a concrete slipway disappears into the sea loch, Loch Scavaig. Across the loch, to the north, in all its majesty is the southern arc of the Cullins. In view were at least eight Monroes, some in shadow others in brilliant sunlight. Cloud streamed off the peak on the left of the group and as I watched the peaks to the right, still sunlit, began to fade as another shower scurried across the island.

Without any doubt whatsoever this was the finest view in Britain – and the late Alfred Wainwright agreed with that.

BAILEY

Travelling around the sea areas and coastal stations has necessitated planning some journeys like a military operation, whereas others have been quite casual trips with the itinerary left flexible.

Some voyages have just fallen into my lap, perhaps a phone call with the offer of a passage. Others have taken dozens of telephone calls, faxes and letters and weeks of planning. Gathering the information for the text has been like that too. I always carry out book research before the journey so I have some idea of what to expect. Occasionally, however, a priceless gem of information will come unsought.

One fascinating piece came via a friend who sent me the torn-out readers letters page from a *Saga* magazine that she had been reading in her dentist's waiting room. Under the heading

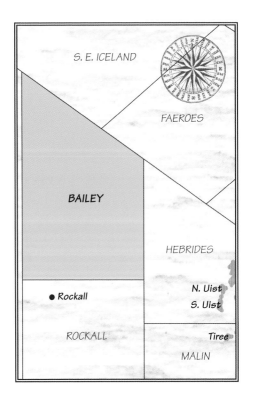

of Bill Bailey's Bank was the following:

When I read [the] reference to the names used in the BBC radio shipping forecast ... I recalled my father's story of one of them. In 1917, as Lt Cdr William Maclure RNR, he was Navigation Officer of HMS *Gloucestershire* of the 10th Cruiser Squadron, on the Iceland Patrol. Their duty was to investigate any vessel not accounted for. A trawler, found to be British, was spotted where it should not have been. Investigation of the ship, which was called *Bill Bailey*, revealed that the skipper was fishing his own 'secret' bank not marked on the Admiralty charts. My father therefore amended the chart to show the bank and labelled it 'The Bill Bailey Bank'. It went into the official records and, according to my father, was the origin of the sea area 'Bailey'.

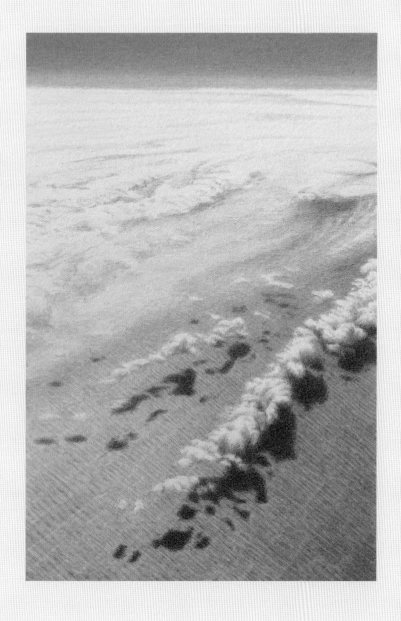

Bailey
Southwesterly 5 to 7 veering northwesterly 4 or 5.
Rain or showers.
Moderate with fog patches becoming good.

Getting out to sea area Bailey presented something of a problem. My most used method of crossing the seas was, on this occasion, not an option. There are no ferries passing through as it is not really on the way to anywhere, except Greenland maybe.

My first thought was to try to arrange a trip out on a fishing boat from the west coast of Scotland or Stornoway. However once this was given serious thought it seemed impractical given the distance involved, and the uncertainty of the weather meant that I could be out for a long time, or just hanging about at a quayside for weeks waiting for an improvement in the conditions.

Perhaps I could persuade the Met. Office to take me on a flight next time they went out that way with *Snoopy*, a Lockheed C-130 Hercules transport aircraft converted into a meteorological research unit. It owes its nick-name to its unusual appearance, caused by the additional probes and blisters necessary for the task. Unfortunately *Snoopy* was out of action for a considerable time for modification.

The next consideration was the RAF. They must fly out that way. I was sure transport aircraft fly to the USAF base at Thule in Greenland. On enquiring, there was the possibility of a flight aboard a Nimrod from RAF Kinloss. They seemed

The view inside. Icelandair hospitality

quite keen. I could write about their part in search and rescue operations. It would be a good PR exercise for them as a BBC television crew would like to film me working. It was just a matter of getting the nod from someone more senior in the chain of command.

No luck there, was the reply. It would be a waste of tax payers money and all that. What was the problem? After all, I'm performing a public service here. I'm a man with a mission to solve one of life's great mysteries, to de-mystify the Shipping Forecast!

So it was back to the drawing board, so to speak. I had become keen on the idea of painting the sea from the air. It all looks so different from up there, the pattern of the waves and the rhythm created by the shadowy stripes of the swell are not so well defined when you are being thrown about on the surface, and the cloud pattern over a much larger area can be better appreciated from the air. Just one picture from on high would illustrate that very well.

The sea is such an interesting subject, every movement of the surface is a unique moment, I could sit and watch it all day. The changing colours are fascinating, and the greatest challenge. Not only is there the sea's own colour to consider, but also that of the sky and land that is reflected in it. The dazzle of reflected sunlight when looking in that direction modifies the colours further, even bleaching them out entirely, and adds strong shadow, which has its own natural colour. It is the endless interaction of these elements caused by the movement of the surface that makes the sea so captivating.

Icelandair suddenly came into my mind. Flights from Heathrow to Iceland must pass right over sea area Bailey. That would be perfect. All I would need would be a day return to Keflavik. I bet they do not get asked for one of those very often.

Since I started on this voyage round our seas I had made many strange requests like that which were often met with a 'did you say what I thought you said?' response. 'I'm painting the Shipping Forecast' has been my plea of mitigation, expecting that to be acceptable.

It took some time for the people at Icelandair to understand that I was looking for a seat on the left of the aircraft going out and the right coming back. This was in order that I could look down at the greater part of the sea area for my painting.

I cannot imagine what the Icelanders thought of this request from what they must quickly have thought of as the mad English painter.

Still, they got me there and I got to look out over Bailey. Perhaps my painting, when shown to them, will go some way to restoring an image of British sanity...

Flying to Reykjavik for the evening was one of the more bizarre journeys I have undertaken since starting my travels. I wandered the streets as if in a dream, making the best of the daylight which lasted almost until midnight. The strange thing was that, having got there, I didn't even have a painting to do.

FAIR ISLE

Smoogro, Steenibroykif, Trondra are all place names in Britain, but a part of Britain where they like to think of themselves as their own people. Here their history, their other-ness, is not clung on to but celebrated as if it were an act of defiance. Here English is spoken in something like a lowland Scots accent, but the vowel sounds and some of the vocabulary give away their Scandinavian ancestry.

'People down south don't realise how far away from Britain we are, they put us in a box on their maps and forget about us. Lerwick is much closer to Bergen than to Edinburgh,' was one comment made to me by a Lerwegian as soon as I showed some serious interest.

There is a definite feeling that one has not just crossed to one of the offshore islands, but arrived

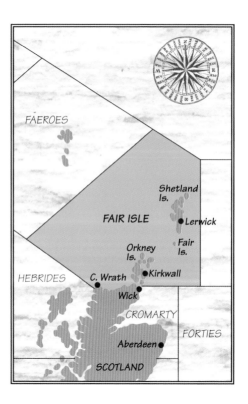

in another country. It is less like Scotland than any of the Hebridean islands but there is still a familiar air about some of the places. Bungalows have begun to take root, and the inevitable Scots baronial architecture crops up at every major settlement. Yet the narrow winding streets and the steep passageways off them in the old parts of Kirkwall and Lerwick have a Norwegian feel to them. On Shetland I came across a word which seemed to capture it well, Shetlandic.

The journey to Shetland from my house in Wiltshire took me two-thirds of the way to the Arctic Circle.

For the first part to Aberdeen I tried a mode of travel I had not used before, but had always wanted to; the sleeper train. The ScotRail Caledonian Sleeper from Euston enabled me to enjoy a good overnight sleep, followed by the unusual

Fair Isle
Southerly or cyclonic 6 or 7 becoming northwesterly 7 to severe gale 9 or violent storm 10 later.
Rain then wintry showers.
Moderate becoming good.

experience of breakfasting while watching the North Sea flash by outside my window. I arrived just before eight o'clock the following morning having travelled more than 850 km, ready to enjoy a day exploring 'The Granite City' before joining the evening ferry to Lerwick.

Ferries to the Northern Isles are operated by P&O Scottish Ferries. This is a most appropriate situation, as Arthur Anderson who founded P&O in the 1830s was born at Gremista on the outskirts of Lerwick, and would no doubt be pleased that his company was maintaining the link between home and Scotland. The crossing from Aberdeen to Lerwick takes 14 hours, 20 if the ferry calls at Stromness in Orkney on the way.

I was thankful for a comfortable crossing, a combination of P&O hospitality and a calm sea. For more than a week prior to my journey the Northern Isles' weather had been exceptionally wintry. Fortunately the crossing coincided with a relatively calm period. I felt refreshed and ready for work as I stepped on deck at seven o'clock the next morning to enjoy a bracing half-hour watching the snow covered hills of southern Shetland slip by on our approach to Lerwick and the delights of the harbourside Queen's Hotel.

The southern boundary of Fair Isle sea area is the northern coastlines of Sutherland and Caithness from Cape Wrath to Wick. In the north-west of the area between the continental shelves of Scotland and the Faeroe Islands lies the Faeroe-Shetland Channel, a deep water trench linking the Atlantic Ocean with the Norwegian Sea. The channel has a slightly smaller surface area than the English Channel but carries 14 times more water, and plays an important part in the circulation of the world's oceans, the 'global conveyer belt'.

Warm surface water flows north to the Arctic where it cools then sinks. This now cold bottom water then flows south, back into the Atlantic, Pacific and Indian Oceans where it warms, rises to the surface and so the cycle continues. Most of the warm surface water passes through the Faeroe-Shetland Channel, as does thirty per cent of the cold outflow.

To the east of the trench the sea is much shallower and here are the two island groups of Orkney and Shetland. Both have a large number of islands, Orkney 90 and Shetland 100, but only a few are inhabited, 18 and 12 respectively.

Although geologically they are quite different, Orkney being mainly old red sandstone and Shetland harder rocks of volcanic origin, there are superficial similarities in their appearance. Neither are mountainous and they are mainly made up of lowlands between rounded hills 150 to 300 m in height. Both have the most glorious coast-lines, with tall cliffs and a great number of stacks and natural arches, especially on their western sides which take a particularly heavy pounding from the Atlantic.

There is a certain amount of rivalry between Orkney and Shetland, so it was a wise head at the

Trawlers with P&O Ferry

Met. Office who named the sea area after the tiny island that sits roughly mid-way between them.

I wanted to paint Fair Isle across the sea from one of the other islands and chose Sumburgh as a likely location.

Sumburgh is a small village at the tip of the long peninsula that is the south of Shetland's largest island, Mainland. I made the 35 km journey from Lerwick by bus, through scattered settlements with names like Exnaboe and Hestingott. At Sumburgh is Jarlshof, the extraordinary remains of a village occupied from the late Bronze-Age up to the seventeenth century, perched on the edge of a low south-west facing cliff.

A brief snowstorm had just ended as I stepped off the bus and I took advantage of a pleasant sunny spell to sketch the view, sitting on the grass beside the remains of a Pictish house. To the south was Sumburgh Head with its lighthouse, once a Shipping Forecast coastal station. In front of me loomed Scat Ness peninsula with Horse Island and, just visible, as a blue silhouette on the horizon 40 km away was Fair Isle.

Just as I had finished sketching the temperature suddenly dropped and a blizzard blew in from the north-west, which I enjoyed from the bar of the nearby Sumburgh Hotel.

FAEROES

I had done my homework as usual. Mid way between Scotland and Iceland, are 18 islands covering 1,400 square km, 113 km from north to south, population 43,400 with about a third of them living in Tórshavn, Europe's smallest capital.

I was as prepared as anyone could be. I knew where to go if I needed to stock up with the essentials; postcards, a fresh sketch book, more film, soap, dried cod, some good chocolate. It was all very useful inform- ation but I still sailed innocently into the Faeroes experience.

The weather was overcast, with the higher ground shrouded in low cloud. I felt I already had some good visual material from our approach to Tórshavn. I imagined painting what Whistler might have called a symphony in grey. Therefore I felt unusually relaxed and allowed myself the

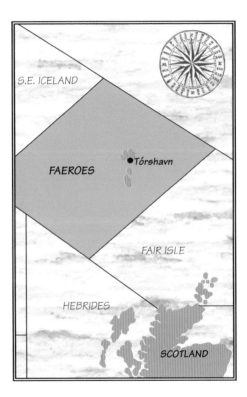

luxury of enjoying my short stop-over. There was even time for a reassuring pinch; I'm really here.

Knowing what to wear at these northern extremities can be a bit of a problem. According to the information booklet I picked up on board the ferry, warm clothing is recommended and a light raincoat *will* prove useful. I was intrigued by the certainty of that. As I was to discover later weather, good or bad, can be very localised. The climate is typically maritime, that is, changeable, but not as cold as one might think for somewhere so far north, thanks to the influence of the Gulf Stream. However, whereas in parts of Scotland one might occasionally experience a whole week's weather in a single day, they claim in the Faeroes it is possible to encounter all four seasons in that one day.

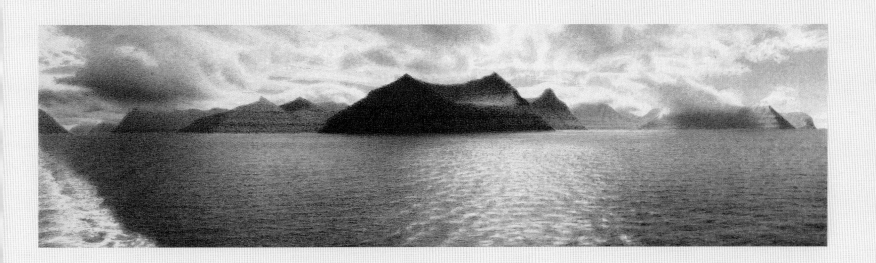

Faeroes
Southerly 6 or 7 decreasing 4.
Occasional rain.
Moderate or poor.

There is a Hebridean feel about the place. Tórshavn has the look of a frontier town, remote and temporary. Buildings are often a ground floor of concrete blocks with an upper floor of painted corrugated iron topped with felt roofs. Older houses are timber, with turfed roofs. Colours are strong, windows large. This is not the place for those who thrive on the little inconsequential luxuries of life; pathological shopaholics would soon come out in a cold sweat.

Fishing is the mainstay of life, then marine engineering.

Over a glass of *Föroya Bjór*, the excellent local beer, I got chatting to a couple of young lads who work a small farm with their father, a minority occupation as only seven per cent of the land can be cultivated. Nearly all of the islands' produce is imported. Even now a main meal will consist mostly of just meat with plenty of potatoes, so what of their diet before the days of refrigerator ships and cargo flights from mainland Europe?

'Lots of fish, fresh and dry salted ... and puffins,' said Kjell.

Oh, how could they? Those cuddly little clowns of the sky with their technicolour beaks and fluffy white faces. I'll confess now, I have eaten braised puffin. And just in case you are interested here are the details: First, you must catch your puffins, one per person.

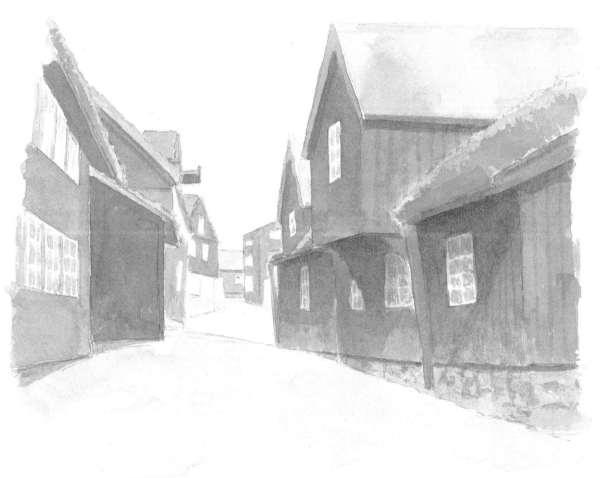

Old Tórshavn

This is best done in November when this year's young are lovely and tender, the puffin equivalent of spring lamb.

The Faeroese use nets on long poles, or something somewhat resembling a lacrosse stick. The net can be dropped over the bird while it is on the ground, or used to swat them out of the sky. Alternatively you can abseil down a 300 m cliff and take them out of their burrows in the cliff face. Harvesting is strictly controlled in order to maintain a viable population as the birds lay only one egg each June.

Kill your puffin by wringing its neck, then pluck and gut it. If you require an anaesthetic at this stage *Föroya Bjór* has an alcohol content of 5.8%.

Traditionally the bird would be salted for keeping. A dry salted puffin would be stuffed with a cake made of breadcrumbs, dried fruit, seasoning and a pinch of sugar and then boiled. Nowadays they are usually frozen. Fresh or defrosted puffin can be very gently fried in butter and served with the juices from the pan to which some fresh single cream has been added.

The meat is dark, a little 'gamey', like duck, with a dense firm texture similar to pigeon, not tough or chewy. Apart from the fine membranes which remained between the layers of flesh after cooking, I found my first experience of puffin to be delicious.

Leaving Tórshavn and heading for Iceland we sailed at first north-easterly.

For 3 pm in early July it was very dull indeed. Cloud was still low but had started to break with bright patches appearing to the north. After about 20 km we turned sharply to port and began to pass down a long fjord open to the sea at both ends. To the left was Eysturoy, one of the two largest islands, to the right Kalsoy, one of the six small northernmost islands.

There followed the most stunning scenery I have encountered anywhere; the most dramatic combination of landscape and weather imaginable. Large breaks in the cloud revealed patches of blue as the sun streamed through in dazzling shafts, which fell in pools of the brightest emerald on a chain of pyramidal mountains rising out of the sea.

I stood on the port deck for two unforgettable hours and watched as this awesome panorama of breathtaking beauty passed by. As we cleared the islands I raced to the rear deck not wanting the excitement to end. There was hardly a free centimetre of handrail. I had obviously been part of a mass jaw dropping. We all stood in silence as the fabulous prospect slipped slowly over the horizon.

SOUTH EAST ICELAND

Soon after entering the South East Iceland sea area we had become enveloped in a cool blanket of fog. We proceeded through the evening and into the night with the fog horn sounding and only radar to reassure us that no one was close by.

Fog at night was not the most inspiring subject I had encountered, and I did not think I had enough charcoal with me to do it justice, so I spent the evening in the bar scribbling and reading. I thought I might go into business importing *Föroya Bjór* beer when I returned home.

Someone who knows about these things once told me that, facially, I am a Huguenot. By my reaction to being on the Faeroe Islands, and my anticipation of seeing Iceland for the first time, there must be a significant amount of Viking in there somewhere.

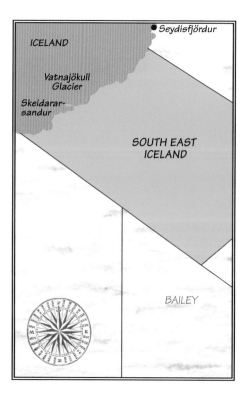

Waking early with a tingle of excitement, knowing that Iceland must be in sight, I was on deck at five o'clock local time, two hours after sunrise. There was no sun and no sky. The deck was wet so there must have been overnight rain. The air was still, the sky hidden by a uniform blanket of grey cloud. The sea was calm and grey. A band of darker grey straddled what I assumed to be the horizon, suggesting that we were probably quite close to land, but it was hidden by a shroud of coastal fog. That was how the scene remained for a few moments, then just above the fog bank the cloud began to glow a little brighter. Suddenly the cloud and fog separated and a strip of blue sky appeared, along with three jagged mountain peaks streaked with snow illuminated by bright sunshine. This wonderful vision remained for less than two

South East Iceland
South-southwesterly 4.
Occasional rain.
Moderate or poor.

fjord settlement, fog clearing

minutes and faded as quickly as it had appeared. The grey returned. It was 5.10 am.

Iceland sits on one of the earth crust's major fault lines, the Mid-Atlantic Ridge, and in geological terms is new, so new in fact that some of it is still finding its way to the surface. This is the place to see mother nature running rampant. Everywhere you go, there she is tearing around, ice bucket in one hand and fire bucket in the other, spilling the contents of each in equal measure as she goes.

The coastline that makes up the north-west side of the sea area can be divided into three regions of more or less equal length. In the northern and central regions the scenery is dominated by mountains, which are separated by many fjords on a north-west – south-east axis, creating an indented coastline in the north. The coastline of the central and southern regions is a product of the Vatnajökull Glacier, Europe's largest which is larger than all those on the European mainland put together.

The southern coast is the Skeidararsandur, a 30 km wide plain of black volcanic sand deposits, the outwash from the glacier, made up of

meltwater and debris from the volcanic activity occurring under the ice cap. The mountains along the central coast mark the south-eastern edge of the glacier, and are separated from the sea by a narrow strip of the black outwash sand. Icebergs float in glacial lagoons which have formed between the coastal strip and the mountains.

Nearly everyone in Iceland lives on the coast, where the climate is surprisingly mild and equable for somewhere so close to the Arctic Circle. Winter averages are around freezing, with summer temperatures about 11°C. Some communities on east coast fjords live in the shadows of the mountains, where the sun does not rise over the peaks until April and disappears again at the end of September. Although these mountains are not high, around 800 to 900 m, snow will remain on south facing slopes throughout the summer months.

The summer brings long periods of daylight, with nearly three months where it is below the horizon for only two to four hours, not enough time to get dark. The down side of this, of course, is that in winter the reverse happens, but then you have the Northern Lights as compensation.

East coast communities are generally small. For instance, Seydisfjördur, which has the terminal for ferries from northern Europe, has a population of only 800. Many are now linked by a coastal ring-road which was completed in the mid 1970s, but the mountainous terrain means that some are passed by, and the only routes out are the road inland or by sea. Most communities started in the latter half of the nineteenth century, either as trading centres or fishing villages. The first half of the twentieth century was something of a boom time and was known as the herring years. They are all heavily dependant on fishing with most having their own processing plant. Usually this means freezing and packing, but some still produce the traditional dried cod; delicious when cooked properly, but not an appetising sight when encountered in its dry state when they resemble strips of starched dish cloth.

After my short stay I was more convinced of having some Norse roots, short winter days and dried cod notwithstanding, which I could not put down entirely to enjoying Noggin the Nog as a child.

COASTAL STATIONS INTRODUCTION

The first weather messages for shipping approaching the western coasts of Britain that were anything more than a gale warning commenced in June 1921. They included weather observations made at 0700 and 1800 GMT at Stornoway, Blacksod, Holyhead, Scilly and Dungeness. This gave mariners some idea of the conditions that the forecasts were based on.

When the first *Weather Shipping* map appeared in 1924 it showed ten reporting stations; Stornoway, Malin Head, Valentia, Holyhead, Scilly, Guernsey, Dungeness, Yarmouth, Tynemouth and Wick. These ten stations were a mixture of meteorological offices, lighthouses and Coastguard stations. The forecast areas were extended in 1932 when two more stations were added to the map, Reykjavik and Tórshavn, but these were removed from the bulletin when the new sea areas were introduced in 1949.

Over the years a small number of changes have been made, extra stations were added and different meteorological offices used, but the greatest changes have been brought about by the introduction of new technology to the lighthouses and light vessels. Their conversion from manned to automatic operation has removed Bell Rock, Butt of Lewis, Dowsing, Galloper, Portland Bill, Royal Sovereign, St. Abb's Head and Sumburgh.

The development of automatic weather stations by the Met. Office has kept reports from light vessels coming in, and has reintroduced reports from the Scilly Isles. In the 1990s great changes were made to the operation of the Coastguard service with the number of stations being reduced.

Such natural changes are a constant feature. Storms whip up around our islands – there are even winds of change at the Met. Office and storms at the BBC. Still, however, the Shipping Forecast remains a valuable tool wherever around our coasts the mariner finds him or herself.

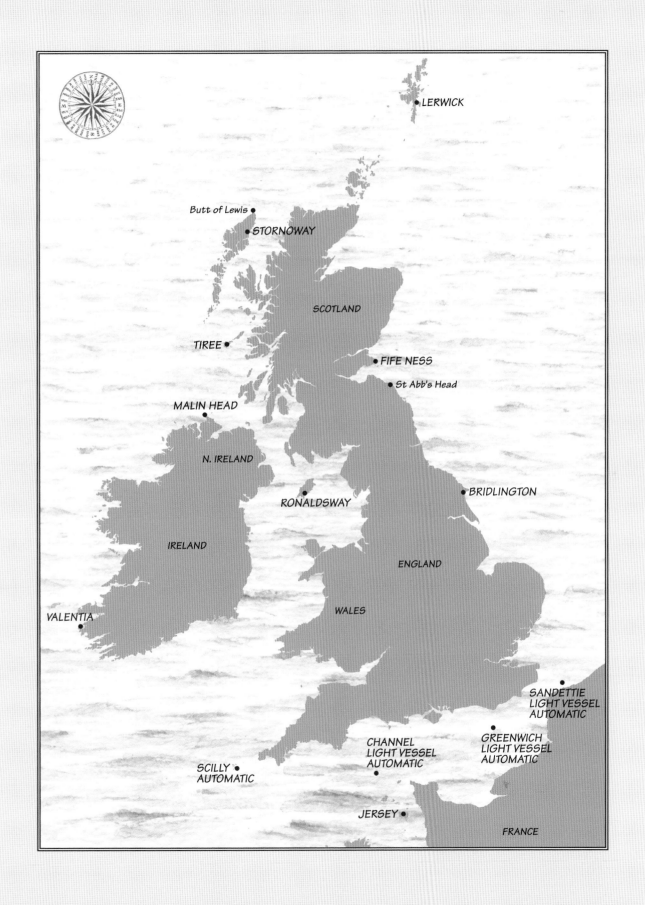

TIREE

Something strange had happened. I was convinced I had boarded the right ferry in Oban. I could remember sailing up the Sound of Mull and turning left after Tobermory but perhaps I had dreamt it. I must have fallen asleep and we had sailed halfway round the world to California.

The warmth of the sun, the wide white sandy beaches, the sea a Pacific Ocean blue; this could not be the Hebrides.

Tir-reidh, Gaelic for the flat land, is a treeless 19 km long sand covered reef, lying north-east to south-west, with a scalloped coastline of dune backed surf beaches. Machair grass stretches from coast to coast and meadows are a carpet of wild flowers. It is still a largely crofting community, with the white painted crofter cottages dotted about the green landscape dominated by huge skies. It is so far north and

west that on the longest day daylight lasts one and a half hours longer than in London, yet it has more hours of sunshine per day in May than Jersey and a similar winter temperature range to the Isles of Scilly. Quite simply it is the most unlikely Hebridean island.

The Caledonian MacBrayne car ferry makes the four hour trip to Tiree and its neighbour Coll five times a week, leaving Oban at 6 am. Usually Coll is called at first, but on Fridays, and I travelled on a Friday, it's Tiree. As we approached the quay at the western end of Gott Bay the island looked as if it could easily be swamped by the wake from the ship.

Coming at the end of a family holiday that had taken in most of the Hebridean islands, and which had been for the most part wet and windy, Tiree was refreshingly different. After depositing our

Tiree
West-northwest 5.
Precipitation within sight.
More than 38 miles.
1001 rising.

California dreaming, Tiree.

belongings at our sea view hotel we set off on a tour of the island. Our first stop was Scarinish Co-op to pick up something for a picnic lunch. Some items were in short supply as we had arrived before they had unpacked the truck that had travelled with us on the ferry. It is little moments like that which bring home how different everyday life is for communities like this.

The island has a population of about 850, only a fifth of its peak in the 1830s before depletion by famine and the clearances. The short lived tourist season means that it cannot be relied upon for a year-round income, so, consequently, hotels and restaurants do not abound. Living is mostly off the land.

Scarinish is one of three villages, all in the southern part of the island, but buildings were seldom out of sight anywhere. We came across many traditional crofter cottages still in use, some greatly altered by modernisation, others preserved to retain their original appearance. A few, either abandoned or converted for another use, sat next to their modern replacements. Occasionally we would find an isolated ruin, a reminder of a harsh history in a gentle landscape.

In the centre of the island is Tiree Reef airfield, which offers regular flights to Glasgow. It is from here that the weather observations for the Shipping Forecast are made.

By mid afternoon we felt in need of a reviving cup of tea, and noticed a small sign at the side of the road pointing down a track to a large Victorian farmhouse, a full two storeys high, quite unlike any other building on the island. Inside we were ushered into what was clearly the living room and sat at the dining table while our host made tea and sliced some Dundee cake. There was another woman in the room who appeared to be in the middle of a basket weaving lesson. This was a most unusual situation.

Inevitably we began to chat.

After our experience in Scarinish I was interested to know how they went about buying a major item, a piece of furniture for instance, or what happens when their doctor arranges a hospital appointment.

'Shopping for small items or clothes? Those sort of things are saved up for a spree in Oban. There's at least one overnight stay as the ferry does not usually arrive there until after two in the afternoon, and returns early the next morning.'

'What if you're after a new bed?' I asked.

'Well, for things like that we shop out of catalogues; mail order.'

'And the hospital appointment? Would that be in Oban too?'

'No, we're flown to Glasgow.'

Island life appeals to a romantic side of my nature. When I return to the mainland I always feel that I'm leaving civilisation behind, not going back to it, but I think I am too used to the conveniences of mainland life to be able to adjust.

The fact that Britain can offer so many islands which can be enjoyed for short periods is probably enough. They do have their special charms. Later we returned to our hotel and had the biggest fish supper ever, great local produce. After the meal, during an evening stroll we encountered some fellow diners who were zipping a tent to the side of their camper-van which they had parked at the head of the beach.

That night they would be lulled to sleep by the sound of the surf. Who needs the tropics?

STORNOWAY

I have always been fascinated by place names, their origin and meaning and also their correct pronunciation. Do we use the generally known name or the one the locals use?

Where I live you can always tell the in-comers by their version of the name, because the locals use an almost phonetic pronunciation, which is quite different. In the Hebrides many road signs are in Gaelic. If you're not conversant with the language, reading them as they are written gives no real clue to the correct pronunciation. Stopping someone to ask the way can lead to some embarrassing conversations. Stornoway for instance is an anglicised spelling. Locally it is Steornabhagh.

The ferry to Stornoway/Steornabhagh sails from Ullapool, a small town on Loch Broom, which had been created in the eighteenth century as a

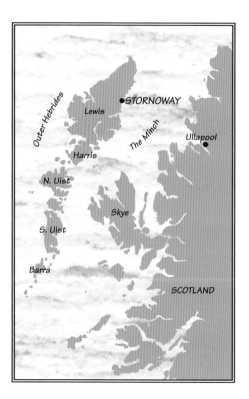

fishing station to exploit the local herring population.

At the ferry terminal the Caledonian MacBrayne flag was as rigid as a sheet of plywood, almost ripping itself off the flagpole, in force 7 wind; not the best of conditions for crossing the Minch. I forewent a pre-sailing meal, which seemed a little pointless as I could not imagine it staying down long enough to do me any good. I had heard the Shipping Forecast for Hebrides and it was not good.

The journey took three and a half hours. The departure down Loch Broom and the arrival at Stornoway were quite calm, but the open sea between offered the longest two hours I can recall. I spent the entire journey clinging to a handrail on a bitterly cold deck being lashed by rain and spray watching a heaving sea as darkness set in. The experience was

Stornoway
Southwest 5.
22 miles.
1012 rising slowly.

'exhilarating'. At Stornoway terra had never felt more firma.

Similar in size to Whitby or Swanage, Stornoway is not unlike many other small working ports around the British Isles, which makes it quite different from every other community in the Outer Hebrides. It is the only town, which in Hebridean terms is a great metropolis; the capital of the Western Isles politically, economically and culturally. Hebrides communities (called townships), because of their crofting history, are scattered over much larger areas than comparable villages on the mainland. Each house sits on a working plot of land, so rows of houses with nothing more than a small patch of garden front and back are quite unusual, but not in Stornoway. Many fine Victorian houses and a good shopping centre are laid out around a large natural harbour.

Here – and nowhere else on Lewis – are trees. Masses of them surround a rather incongruous nineteenth century Tudor-style castle which is perched on high ground across the harbour from the town. Apparently soil was imported by the boatload from the mainland to give them something to grow in.

I was so pleased to feel the warm sun and to be recovered from the experience of the crossing. The colourful fishing boats were almost dazzling after the dark greyness of the previous day. I decided immediately that this would have to be my image for Stornoway – a small intense burst of colour.

To see how people once survived the often inhospitable climate I drove out to the nearby township of Arnol, where there is an example of the traditional building, the black house, in its original form. It is preserved by Historic Scotland and open to the public.

A type of long house, the people often lived under the same roof as their animals. Constructed

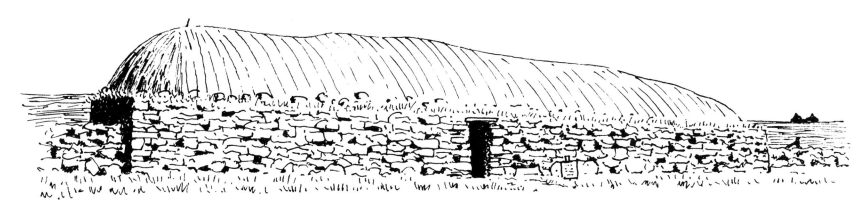

Arnol Black House

of rubble stone, the walls are double skin with an earth core, about 2 m high and 2 m thick with rounded corners. The roof, rising from the inner wall, is thatched with straw and held down with ropes weighted with stones. The top of the outer wall is turf, which provides grazing for sheep – an arresting sight on first encounter. The floor is stone slabs. Typically, this black house has only one window and no chimney. A fire was lit on the floor over which a kettle was hung on a chain from the ceiling. The air was thick with peat smoke, not an unpleasant experience for a short time, but that is the romantic in me coming out; I have not spent my entire life in these conditions.

The knitted Harris tweed slippers I bought there are wonderfully warm in winter, and their peat smoke smell lingered in my house for many weeks as a reminder of my visit.

The Arnol township has many black houses, nearly all now ruined and roofless, and about an equal number of modern bungalows. Each one sits on a long strip of land in something like a pre-enclosure landscape.

If, like me, you have ever pondered the Celts' penchant for bungalows, you only need to come here to realise that it is a simple matter of wind resistance and how to reduce it.

Discovering regional food is one of the joys of a journey of this kind and during my visit I enjoyed Cranachan.

To make this delicious dish, toast one ounce of oats, then set them aside to cool. Whip together one pint of double cream, three tablespoons of whisky and two tablespoons of honey until it forms peaks. Fold in four tablespoons of thick natural yoghurt (or the Scottish soft cheese Crowdie, if you can get it) and when you are ready to serve add the oats to this mixture.

Put one ounce of raspberries into each of six serving glasses and top with the cream mixture. I had this without the usual raspberries yet it still reached force 10 on the tastebuds' Beaufort scale.

LERWICK

The Shetland Islands ceased to be a part of Denmark in 1469 when James III of Scotland married Princess Alexandra of Denmark and the islands were ceded to Scotland as part of her dowry. At that time Lerwick was a small fishing community overlooking Bressay Sound, a large, well sheltered natural harbour. Development of the site was encouraged by the presence of Dutch herring fleets and Hanseatic League merchants trading Shetland salt cod with the towns and cities of the North Sea and Baltic. Lerwick has since grown into the islands' busy capital and only town, the most northerly in Britain. It is as close to the Arctic Circle as St. Petersburg and Anchorage.

Lerwick lives its history. This is not just

apparent from a tour of the displays in the museum; it is there on the streets and in the harbour, in the names of lanes and shops. The impression is that the town's character and preoccupation is derived from two sources, the Vikings and fishing.

I visited Lerwick in that late winter – early spring period when the town would be itself, free from tourist activity, and, from a practical working point of view, past winter's darkest days. Unfortunately this meant missing the January festival of Up Helly Aa, where Shetlanders celebrate their roots and the return of the sun after the shortest days with a torchlight parade through the streets, culminating in the ceremonial burning of a replica Viking longship.

As the Aberdeen ferry approached the Knab headland to the south of the town, we passed a

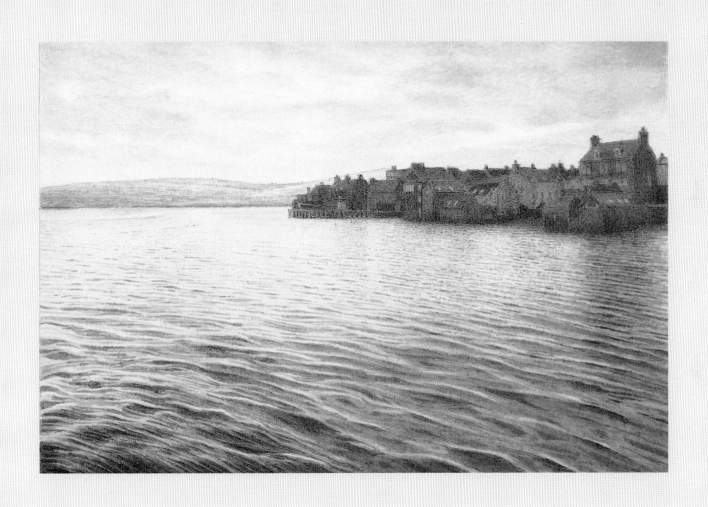

Lerwick
West-northwest 3.
22 miles.
1007 rising slowly.

group of moored Russian klondykers, looking like hulks making their way to the scrapyard. They would probably be out here for six months before returning home, evidence of how rich the fishing grounds here are. Beyond the Knab Lerwick came into view, looking a jolly jumble of buildings.

The town's heart is the harbour, a long curving waterfront always busy with the comings and goings of ferries, trawlers and North Sea oil support vessels. Parallel with the harbour the paved main street, Commercial Street winds its way through a narrow gorge of old granite and sandstone buildings. At regular intervals along the street gaps in the shop fronts reveal narrow lanes, with long steep flights of steps climbing up to Fort Charlotte, the grand Victorian Town Hall and residential Lerwick spreading across the hill behind.

Booking accommodation in advance is always a bit of a gamble but on this occasion I hit the jackpot. The Queen's Hotel in the oldest part of town is one of the old Lodberries, houses with piers where goods could be unloaded directly from boats. The sea lapped against its walls.

From my room I had a magnificent view across the sound to the snow streaked island of Bressay, a perfect view for determining the day's weather prospects.

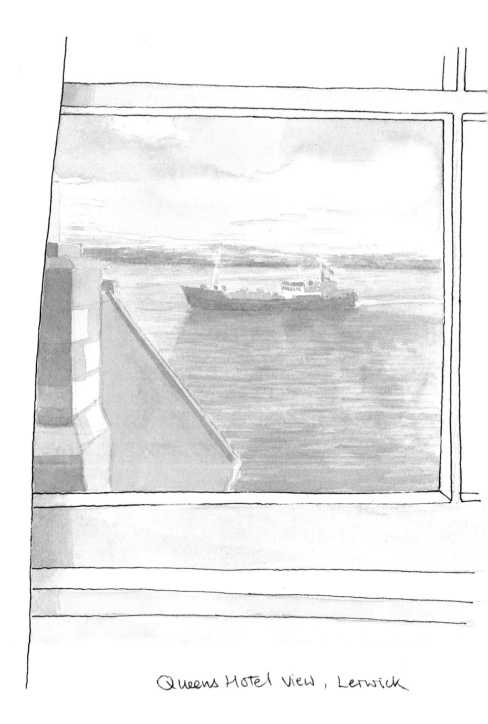

Queens Hotel view, Lerwick

Seals swam among the seabirds and trawlers eased themselves in and out of their berths next door. Within moments I could be on the quayside next to the lifeboat, watching trawlers from the mainland as well as from local ports unloading their catches.

Lerwick is fishing. There are so many fishing related activities in and around the town, with even a specialist newspaper, the *Shetland Fishing News*, that I spent much time exploring them and enjoying their produce.

With income generated by Shetland's other main industry, one penny for every barrel of North Sea oil that flows down the pipeline to the Sullom Voe terminal, the Shetland Islands Council has been able to invest in many projects to help safeguard the island's long term future. One of their most impressive achievements is the North Atlantic Fisheries College, which I stumbled across when in search of refreshment and some respite from the incessant rain on a wet afternoon in Scalloway.

'Restaurant open to the general public' is not the sort of notice one expects to find outside a college building, so I had to investigate. The college is unique, running courses on everything imaginable connected with fishing and the sea. This can range from a simple one-day workshop on preparing fish at home, to full time courses in seamanship, marine engineering, oceanography, fish farming and processing. They even have their own inshore fishing vessel, salmon farms and

processing plant, and have developed new fishy products such as fish sausages. I came away suitably refreshed and enlightened.

At Skeld, a short boat journey across The Deeps from Scalloway, I paid a fascinating visit to the Shetland Smokehouse. Here I donned white smock, cap and disposable shoe covers to see salmon, mackerel and some cod and haddock smoked in as natural a way as possible, without using artificial flavourings or colourings. The fish were being cured cold, over oak sawdust, shavings and chippings to which some beech had been added, the oak coming from old whisky barrels from the mainland. The results were just wonderful.

All this was whetting my appetite for dinner. I had enquired about local seafood specialities and the Kveldsro House Hotel in Lerwick came highly recommended. Mark Gibson their chef was 'the best', and I was not disappointed. I had not had anything like it before, the mouthwatering menu was a meal in itself. Four heavenly fish courses were prepared from catches landed at the quayside that morning: Shetland smoked salmon, the most tender squid I have ever tasted, pounded sole with cream and nutmeg, steamed mousse of monkfish and Fair Isle lobsters – fabulous! I could have had the sauteed catfish in oyster sauce, creamy bisque of Bressay crab or griddled king scallops.

Such are the benefits of doing a book about the Shipping Forecast in a place which at times seemed more Venetian than Viking.

FIFE NESS

There is an old Scottish word, neuk which means a retreat, a secluded or sheltered place.

Lying between the Firths of Tay and Forth is East Neuk, a peninsula of generally low lying country, with the small university city of St. Andrews in the north, and a string of pretty coastal villages in the south. This may be a pleasant secluded out-of-the-way place, but it is no backwater, it is an area with a rich history. The villages have royal burgh status, and all have some superb sixteenth and seventeenth century buildings of a quality and style much greater than one would expect to find in fishing villages of their size.

This is a reflection of the significance of their past trading links with Scandinavia and the Low Countries. The ruins of a great cathedral and castle show that St. Andrews, too, had, until the

Reformation at least, a more glorious past. It was one of the most significant places in Scotland.

The crow stepped gables of the buildings and the cobbled streets give a Flemish feel to the city.

Today for most people St. Andrews means just one thing. It is the home of golf. For many that means it is the centre of the world – not a sentiment I share.

In the centre of Crail, the most easterly of the East Neuk fishing villages, the linking road turns towards St. Andrews. From that junction a minor road leads out of the village in an easterly direction across an abandoned airfield, complete with its hangers, accommodation huts and overgrown runways. At the northern perimeter of the airfield and surrounded by farm buildings stands what remains of Balcomie Castle. This was home briefly

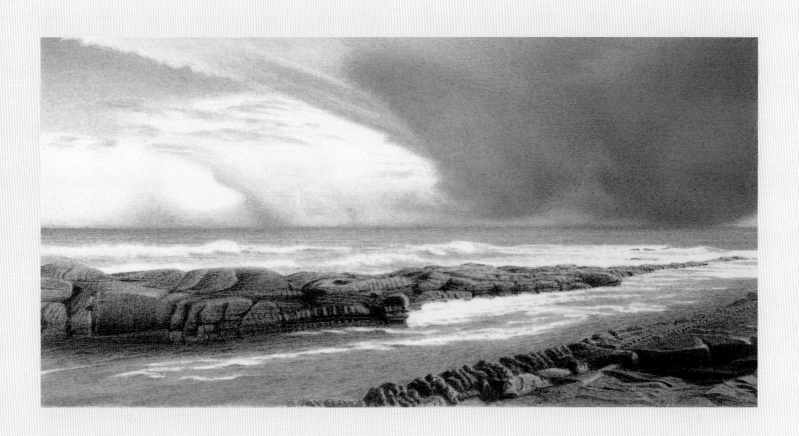

Fife Ness
West-southwest 3.
16 miles.
997 rising slowly.

for Mary of Guise, Queen Consort of James V of Scotland and later Regent of Scotland, the mother of Mary Queen of Scots.

Nearby is the long-abandoned village of Randerston and also the site of an earlier Danish settlement. At about 3 km from Crail the road comes to an end at a small public car park next to a golf club house. From here an undulating track, still just suitable for vehicles, leads off to the right of the clubhouse, passing one of the greens and on to a small coastguard station on a rocky foreshore.

This is Fife Ness, infuriatingly bang on the main fold of the Ordnance Survey map 59.

The foreshore all along the coast of East Neuk is a landscape of sea-washed ledges of volcanic rock exposed at all states of the tide. In places these stretch far out into the sea, unseen but only just below the surface. Offshore at Fife Ness is an outcrop, Carr Brigs, now with a beacon mounted on the furthest rock but once the station of North Carr light vessel.

Next to the coastal footpath, on the shore

rock ledges, Fife Ness

behind the clubhouse by a small beach is the cave of King Constantine, a Scottish king who was murdered there by Danes in 874.

My arrival at Fife Ness late one afternoon in early May coincided with a sunny period on a day of heavy blustery showers of sleet and hail.

The climate here generally is relatively dry, with average rainfall a meagre 500 mm; a level any British coastal resort would be proud of. However that does not necessarily equate with lots of summer sunshine. The area is often kept cool by the haar, a North Sea mist which frequently blankets the area.

Fortunately the tide was receding and I was able to walk out carefully across the rock ledges to enjoy a better view along the coast. From here it must be possible to see virtually all of the Forth sea area, which is one of the smallest. To the north, looking across St. Andrews Bay, I could see the links at Carnoustie on the far side of the Firth of Tay and then along the Angus coast way beyond Arbroath. To the south was the Isle of May 9 km away, with its lighthouses and ruined priory against a backdrop of the coast down to St. Abb's Head. To the right of May was a fabulous view of East Lothian and the Lammermuir Hills with Bass Rock and Berwick Law standing out clearly.

The previous day had seen winds from the north gusting up to gale force 8. Overnight and during the day they had dropped back to a mere force 3 from a more westerly direction. As I walked around the headland by the coastguard station I noticed yet another heavy shower moving slowly along the southern side of the Firth of Forth.

Although I was still standing in brilliant sunshine the sky was beginning to fill with a heavy grey band of something wintry and the land to the south began to be obscured, with the Bass Rock the last to succumb. I found myself looking out on a scene filled entirely with moisture and made a hasty retreat to the car before I became engulfed myself, yet again.

BRIDLINGTON

Bridlington is really two towns in one. The old town is one mile inland with a more recent resort which has developed along the sea shore. It has been a fishing port for more than 1,500 years. The fishermen use locally built boats known as cobles, their shallow draught allowing them to be hauled ashore in the worst of weather conditions.

Bridlington Bay is formed by the chalk peninsula of Flamborough Head to the north of the town. On either side of it are two coves, North Landing and South Landing. Fishermen used to keep a coble at each so that one could be launched which ever way the wind was blowing.

In the days of sail, when a constant stream of colliers passed down this coast carrying coal from Newcastle to London, Bridlington Bay offered shelter from severe north-westerly winds. On one such night in 1871 the wind turned to an easterly trapping some 400 vessels in the bay. More than 30 sank and many sailors were drowned.

A good number of the ships were said to be over loaded and as a result there was pressure to prevent ships from sailing dangerously low in the water. The insurers Lloyd's had the idea of putting a mark on the side of all ships that would clearly indicate to their inspectors that a ship was not overloaded. The idea was championed by the Derby MP Samuel Plimsoll, whose name has become synonymous with the universally used system, now improved and more correctly known as the International Convention Loadlines and Tonnage Mark.

On a fine day it is a good healthy walk from the town to Flamborough. At Sewerby, on the

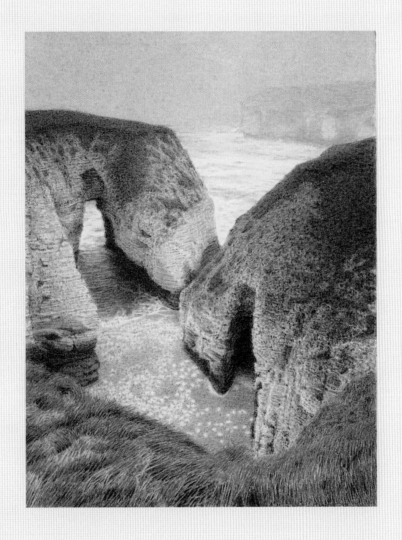

Bridlington
South-southeast 4.
Intermittent slight rain.
1½ miles.
990 falling quickly.

northern edge of Bridlington, the sand gives way to chalk cliffs which rise gently to a plateau of about 50 m at Flamborough Head.

On my first visit I used the car, arriving at a quarter to nine, about the same time as daylight. It was February, grey and overcast. An onshore wind drove rain off a cold North Sea and visibility was poor. The scenery, however, more than made up for the conditions. These are chalk cliffs at their best, as good as Studland in Dorset or the Needles on the Isle of Wight, with coves, stacks and natural arches. Unusually, and a great bonus, a good foot-path leads to the shore in Selwicks Bay, a small cove just to the north of the lighthouse.

The tide was out but rising and I explored the base of the cliffs; a rare treat as scenery as good as this is usually inaccessible at sea level on foot. A stack stands clear of the promontory on the south side of the cove and the occasional large wave crashed against its base in spectacular foaming spray. In my excitement I forgot to keep an eye on the water level at the shoreline, which was rising considerably with the larger breakers. Consequently I received a good soaking, resulting in soggy socks for the rest of the day.

When I started on my voyage round the Shipping Forecast I wore the country clothing I don when walking my natural habitat, the Marlborough Downs in Wiltshire. Without having given the matter much thought before, I suppose I was a fair weather painter. Keeping an eye on the sky out of my studio window I could pick the ideal conditions for a location I wanted to paint. A waxed cotton coat was good enough if I was unfortunate to be caught out by a shower.

When it came to painting the Shipping Forecast this all changed. Some journeys needed to be planned well in advance, like a military operation, with no telling what the weather might be when I arrived. Indeed, the nature of the project meant spreading the journeys out through the seasons, trying to ensure that I experienced as many different weather conditions as possible.

I eventually realised that a poorly maintained waxed coat is not the ideal attire for a day tramping a windswept cliff top in torrential rain. The seams are where the dam begins to burst. Consequently I took the 'when in Rome...' advice and acquired a Henri Lloyd jacket as seen on all the best dressed yachtsmen. It is designed to cope with foulest of weather at sea, is worn by crews in round the world races, is lightweight, breathable and totally waterproof and, importantly, it is bright red. So if I had a shoreline mishap in a remote location I could be spotted more easily. In my new habitat I acquired new plumage.

The Humber Coastguards, based in Bridlington are those who deal with shoreline mishaps, but also they are responsible for making the Bridlington meteorological observations which appear in the weather reports from Coastal Stations. The observations are made every hour, but this is sometimes not possible when they are responding to an emergency.

East coast cobles

In coastal areas the coastguards are the fourth emergency service, reached by a 999 telephone call or by using the maritime radio distress frequency. After a call has been received they assess the situation and if it is decided that they have a search and rescue emergency it is they who co-ordinate the other services; RNLI lifeboats, Royal Air Force or Royal Navy helicopters or aircraft, police, fire brigade and ambulance services. They have their own cliff and mud rescue units, a small fleet of patrol boats and helicopters specially equipped to carry out rescues at night and in bad weather.

At Bridlington they are responsible for monitoring the coastline from Whitby in the north to Humberston near Cleethorpes in the south. Out to sea they cover as far as the international boundary with Denmark and Holland, although in practice if an emergency occurs in that vicinity it is always the safety of those in peril that is the first consideration, and it is simply a matter of who can get there first.

SANDETTIE, GREENWICH & CHANNEL LIGHT VESSELS

The first light vessel was placed at Nore Station in 1732, marking the dangerous sands where the River Medway enters the Thames. This was an entrepreneurial exercise by two private individuals who financed the venture by levying a toll on passing ships, probably a figure of about a farthing per ton. At that time keeping the vessel in its correct position, and finding a crew willing to work it must have presented a few problems.

Initially Trinity House was opposed to the idea. The scheme, however, was a success and was adopted by the Brethren who eventually took over the vessel from its original owners. The levying of light dues on ships loading or discharging at UK ports, based on net registered tonnage, is still the method by which Trinity House funds its lighthouse service.

Until 1989 light vessels were manned, a job which, to coin a well worn phrase more appropriate here than anywhere, must have had its ups and downs. With a July sun beating down on a flat calm sea it must have been idyllic with just the sound of the sea lapping against the hull, but imagine being caught in a force 10 gale unable to run for shelter, or living for days on end with the fog signal's blasts reverberating through your internal organs.

Those with longer memories of the Shipping Forecast will remember the manned light vessels once used as coastal stations; Dowsing, Galloper and Varne. Fifteen times a day one of the five crew members would take the readings, observe the sky and hold the anemometer aloft, reporting the results to their local coastguard station which passed the message on to the Met.

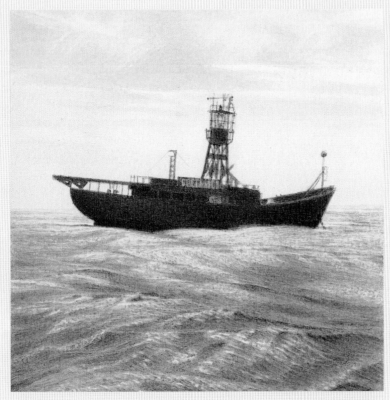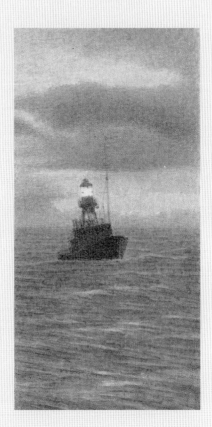

Greenwich Light Vessel Automatic
South 5.
16 miles.
1006 falling slowly.

Office. It must have been a great comfort when the month's duty was drawing to an end, to hear their few seconds of fame on the radio, knowing that they had not been forgotten.

Not forgotten but gone. During the 1980s technological advances made it possible for the Trinity House fleet of light vessels to be converted to automatic operation. Each is linked by radio to a shore-based station monitoring the performance of the ship's various navigational aids and ensuring that it remains in its correct position. The vessels are now fitted with a helicopter landing platform allowing maintenance crews to be on the scene quickly in the event of a failure.

The Trinity House fleet is 14 strong but only 11 are in service at any given time. There is usually one in dry dock and two moored ready for service, either as a routine replacement or in case of accident. The ships' stations, that is their locations, are named but the vessels themselves are numbered.

A ship will remain on station for four years, after which it is returned to the depot at Harwich for routine maintenance, to be replaced by a different vessel. The ships have to be towed as they are not self-propelled, the generators on board are there solely to provide power for the ship's beacons, visible, audible and electronic. A programme is under way to convert the vessels from diesel to solar power.

The de-manning of the light vessels provided the impetus for the Met. Office to develop an automatic weather station, which could also be used on a network of tethered buoys to provide regular seaborne readings from a number of fixed positions. The three light vessels regularly appearing in the Shipping Forecast are just such stations.

Each automatic weather station measures wind speed and direction, air pressure, humidity, air and sea temperature, wave height and period, and visibility. The latter is determined by measuring the scatter of light that returns from a light source, an indication of the density and type of atmospheric moisture. Wave information is measured by a heave sensor, a weight suspended on fine wires that sways with the ship's motion. The rate of acceleration of the weight is converted into an indication of the swell. The wind speed and direction, because of constant fluctuations is determined by taking a mean of the readings over a ten minute period.

Every hour on the hour the data in digital form is transmitted 36,000 km into space to Meteosat, a geostationary weather satellite belonging to Eumetsat, a conglomerate of European meteorological services. Meteosat sends the data to their headquarters in Darmstadt, from where it passes down the telephone lines to the Met. Office in Bracknell.

The first automatic weather station to become a Shipping Forecast coastal station was Smiths Knoll Automatic off Great Yarmouth. The three in current use are all on light vessels in the English Channel.

OUT WITH A BBC FILM CREW ON THE NEWHAVEN LIFEBOAT TO VISIT THE LIGHT VESSEL
— SEA SICK IN FULL VIEW OF THE CAMERA —

JOKE: SEA SICK SAILOR 1: 'WEAK STOMACH EH?'
 SEA SICK SAILOR 2: 'WHAT DO YOU MEAN WEAK STOMACH? I'M THROWING IT AS FAR AS YOU ARE!'

SUFFERING FOR MY ART!

Sandettie, off the French port of Dunkerque, formerly under the control of the French Lighthouse Service, became the responsibility of Trinity House when territorial waters were revised in 1987. It replaced manual readings made by Dover Coastguards.

Greenwich, anchored on the Greenwich Meridian 37 km off Newhaven, replaced observations from the modern concrete lighthouse on the Royal Sovereign Shoal off Hastings, previously marked for over a century by a light vessel.

Channel light vessel is on the south side of the Channel approximately 40 km north-west of Guernsey.

The aspect of light vessels that struck me most when I first encountered one was their size. They are much smaller than I had imagined. While not wanting to demean them, considering the nature of their work and lack of propulsion, perhaps we should think of them as ship-shape buoys.

Those wishing to encounter one first hand need not put to sea, there are a number of redundant vessels around the country, some in maritime museum collections and some adapted to other uses. Ferry passengers using Harwich, are likely to see Trinity House's spare vessels moored close to the ferry dock entrance.

JERSEY

Tax haven, fishermans' sweaters, potatoes to die for, Lily Langtry, cream-rich milk from glamorous cattle: It's a place everyone knows of, but probably knows little about. One of *Les Îles Anglo-Normandes*, the most southerly of the Channel Islands, it is not really in the Channel but the Gulf of St Malo.

Locals will tell you that England is their oldest surviving possession, a claim which has a certain amount of logic. In 911 the Viking Rollo took control of Normandy from Charles the Simple of France. Later, the Channel Islands were added to the Duchy by his son William Longsword. His descendant William II became the Duke in 1035 and won the English crown at the Battle of Hastings. Here began the Islands' loyalty to the English crown, which continued even when King

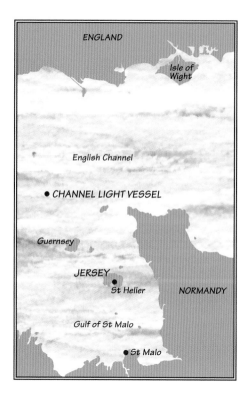

John lost Normandy to France in 1204.

The British parliament has little power here. Rule is by their own parliament known as the States, which is non-party-political with unpaid represent-atives. The president of the States is the Bailiff. The line of power then goes to the Lieut-enant-Governor (the Monarch's representative), the Home Sec-retary, the Privy Council and ultimately the Throne.

If William the Conqueror were to return today he would be familiar with the legal system, which remains essent-ially Norman, with officials bearing such titles as *jurat* (justice of the peace), *procureur* (prosecutor) and *greffier* (clerk). He would also be able to follow the local patois, Jersiais, which is incomprehensible to contemporary visitors from England or France. The English/French mix is

Jersey
Northwest by north 5.
24 miles.
1028 rising slowly.

therefore more than simply English speakers on an island with French place names. It cuts right through a thousand years of life from top to bottom.

History and its geographical location just 22 km off the French coast have contrived to turn Jersey into a fortress. Defensive structures are visible from virtually every point on the coast. Falling broadly into three historic periods; late medieval to Elizabethan, Napoleonic and World War II, they can be placed into three visual categories, respectively; romantic, curious and sinister.

Most romantic of the romantic are the two castles that perch on rocks at either end of St Aubin's Bay on the southern coast. Both Elizabeth Castle and St Aubin's Fort are surrounded by the sea but are accessible on foot at low tide when the massive tidal range exposes a vast stretch of sand.

Round the island's coast, and on many rocky outcrops offshore are a plethora of round towers. Some are Martello Towers, plain and squat, others the more attractive Jersey Round Tower, taller and tapering with wing-nut tops. These come from the Napoleonic era.

The German occupation during World War II produced the island's most extensive fortifications,

le Moulin De Lecq
Jersey

this time in concrete, for which one million tons of sand was removed from the Royal Bay of Grouville. The most striking remains are the three round artillery co-ordinating towers on cliff-edge locations. The one overlooking Corbière now belongs to the Jersey harbour authority. It has been topped with an airport style observation platform and controls shipping as 'Jersey Radio'.

This is not meant to give the impression of a battle-scarred island with ugly artillery emplacements at every turn. With the exception of the

elderly castles, each of which is extensive, impressive and picturesque, the fortifications are overwhelmed by the island's great natural beauty, particularly the dramatic coastal scenery.

Jersey is quite small, 17 km from east to west and about 7 km north to south, but much larger at low tide. It is a slab of pink granite tilted to face the sun, with high cliffs in the north and gentle sandy bays in the south. The combination of landscape and climate are ideal for early season crops.

To get a feel for the coastline I made an anticlockwise circuit of the island, along the narrow leafy lanes.

For much of the west, south and east coasts there is a coastal road, with sea views for those not at the wheel. The north coast is different; high, rugged, dramatic with a series of craggy promontories with extensive views of the other islands to the north and France to the east, interspersed with pretty bays, most of which have small villages nestling round little harbours.

I was seriously spoilt for choice. Apart from St Helier, which is remarkably unremarkable, the whole of the coastline is absolutely beautiful. I settled on the bay at Grève de Lecq, where at low tide an isolated granite ledge, with sea on three sides, can be reached. On top of the hill to the east of the bay is an Iron Age hill fort, a reminder of the landscape near my home.

Although this was a bright sunny day, a fresh north-westerly was blowing and I was glad to retire to the warmth of a nearby inn, Le Moulin de Lecq. Formerly a watermill, the wheel and its mechanism are still in place and turning, making an eye-catching bar feature. The inn was busy with folk enjoying the holiday sunshine, but I was fortunate to find a table with a bar view. Supping my excellent pint of the local *Mary Ann* bitter I self-consciously sketched the bar.

This had been my first visit to Jersey but I felt I already knew it well. Many place names were familiar from family reminiscences, my mother-in-law was born a Le Masurier, one of the commonest names on the island, and for my wife it was something of a homecoming. We found time to visit long lost relatives, and to celebrate with the family dish of Jersey Wonders – delicious sweet knotted doughnuts.

SCILLY AUTOMATIC

The Isles of Scilly (or just Scilly but never The Scillies) are a 16 km wide archipelago of fifty-four named islands and many more rocky outcrops at the entrance to the English Channel, 45 km west-south-west of Land's End. The inhabited islands number only five, perhaps six, as two are joined by a sand-bar at low tide.

I made the 68 km crossing from Penzance on the ferry *Scillonian III*, which is met at Hugh Town quay St. Mary's by a host of smaller launches waiting to ferry passengers to the 'off-islands', as the other inhabited islands are known. They are all low lying, the highest point being on St. Mary's and that at only 57 m above sea level.

The main islands are separated by a shallow lagoon and wherever there was a view across it I could not help but stare, transfixed by the beauty of it, but at the same time puzzled by the strange

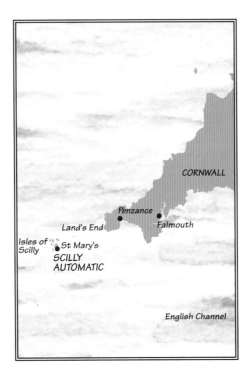

lack of a sense of scale. One could imagine the huge waves of Atlantic winter gales washing everything away, but miraculously the mass of ledges and rocks lying submerged or semi-submerged throughout Scilly break up the stormy seas.

Here lies the interest for divers, for those protective rocks and ledges have made the area a ships' graveyard on the grand scale, with at least 800 wrecks recorded. Shipwrecks are far less frequent now, however. The hazards remain but modern technology makes for a safer passage.

With these waters having a reputation for danger I decided that an interview with a member of the St. Mary's lifeboat crew was a must. On an island so small I was not amazed to find that the proprietor of my guest house is the acting engineer, so we arranged to meet one morning at the lifeboat station. That was not the only stroke

Scilly Automatic
Southwest by West 4.
24 miles.
1025 falling slowly.

of luck. From my window I could look out across the south-west corner of the island and see the automatic weather station at the airfield. As so often on this journey my reason for being there was right outside my bedroom window.

My first full day on Scilly was a trip out with an old friend Doug Chalk and his fellow divers. We anchored over the remains of the *SS Lady Charlotte*, a collier bound from Cardiff to Alexandria, which went down off Porth Hellick, St. Mary's, in dense fog in 1917.

While the divers were under water I sketched the scene around me. The gig *Bonnet*, built in about 1830, passed by on a training exercise. Gigs are six oared rowing boats, originally built to carry Scillonian pilots out to approaching ships. Now they are raced, by teams of women on Wednesday evenings and men on Friday evenings. A great attraction for visitors, it is the most popular summer sport here.

This sea excursion was followed by a walk to Penninis Head, where massive blocks of granite have weathered to dramatic effect; nature's Henry Moore sculpture park.

On day two I went down to the lifeboat station. St. Mary's is one of those sites where the lifeboat house is a barn at the top of a slipway. In this case as with many others, lifeboat technology has produced a vessel too large for the home of its predecessors and it is moored in the harbour, the preferred option if conditions are suitable, allowing for a faster cast-off.

The slipway now launches the much smaller craft used to take the crew out to the moored

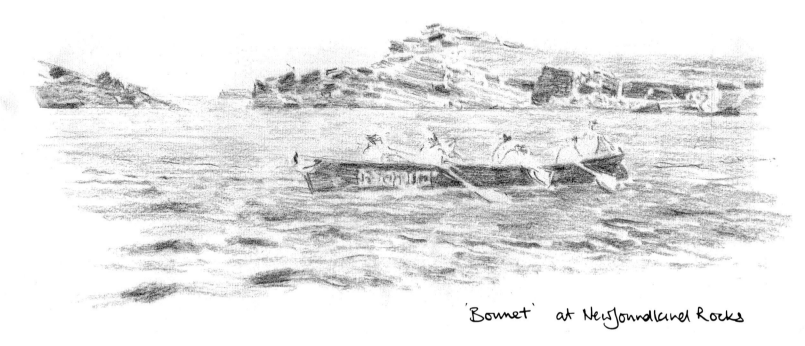

'Bonnet' at Newfoundland Rocks

lifeboat and the redundant half of the building is an exhibition area detailing the histories of the boats and their crews. It is quite clear from the list of rescues that they are called out much more frequently now, usually in the summer months to pleasure craft in trouble or with a sick crew member.

Some rescues can be a test of endurance. For instance, when the *Torrey Canyon* ran aground on the Seven Stones reef in 1967 carrying 119,000 tons of crude oil, the lifeboat stood by for 32 hours before taking off most of the crew.

Another launch which must have been particularly distressing for them simply reads: '1981 – December 20th, Penlee lifeboat *Solomon Browne* – recovered wreckage.' The *Solomon Browne* had gone to the aid of a coaster *Union Star* in the worst imaginable conditions, a force 12 hurricane with 20 m waves and visibility down to a few yards. Both vessels sank. Despite a long search no survivors of either boat were found. Such is the brave and occasionally tragic life of the lifeboat men.

At St. Mary's there are sixteen crew members available and they launch with seven. Essential are the coxswain and the engineer, or in their place a helmsman and an acting engineer, plus the next five to arrive. Their protective clothing is stored next to the launch. Each crew member has his own but at one time, in the days of so'westers, there were just seven sets and whoever arrived first put them on regardless of fit. Today the clothing is more tailored to the task.

Here their initial call comes from Falmouth Coastguard who monitor distress calls. The secretary is then informed and if there is agreement that the boat should be launched the coastguard activates the crews' pagers or he telephones around. The individual members each have their different skills to bring to the team, some are good at dealing with medical problems, others at heaving on ropes, although any permutation of seven from 16 would make a good crew. All are capable of taking the helm and operating the communications and navigation equipment.

The marvellous thing is that lifeboat crews are all volunteers financed entirely by voluntary contributions through the RNLI – and they wouldn't, it seems, want it any other way.

VALENTIA

My limited knowledge of the Spanish Armada includes the fact that after their defeat at the Battle of Gravelines the survivors, because of the weather, made their way back to Spain via an anticlockwise journey round Scotland and then down the west coast of Ireland. From this I had wrongly assumed that the island of Valentia, off the west Kerry coast, was probably named after Valencia in Spain by an Armada crew washed up there after a ship-wreck. The name is actually derived from the old Gaelic *Bheil Insa* – the island at the river mouth.

Valentia is 11 km long and 3 km wide, lying on a south-west/north-east axis. I will admit to being a little disappointed when I first caught sight of the island. Viewed from the mainland the land slopes gently up from the water to an undulating ridge

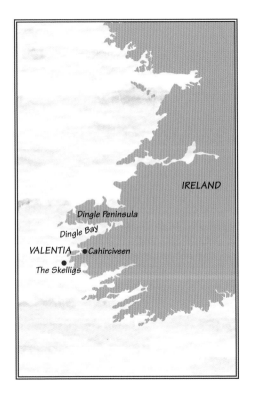

which peaks at 270 m. Lush green, and neatly partitioned into rectangular fields separated by thick broad hedgerows, the image Valentia presented to me and to the mainland is one of good, well-ordered farming country with a scattering of isolated houses and smallholdings. I was expecting something more rugged, wild and weather beaten.

From the small mainland village of Portmagee I crossed the low Maurice O'Neill bridge spanning the channel between it and the western end of Valentia. The island lies so close to the mainland that the channel looked more like a broad river than a coastal sound. Before the bridge opened in 1970 Valentia could only be reached by ferry. Two still operate during the summer months into the island's main town and port, Knightstown, at the north-eastern tip of the island.

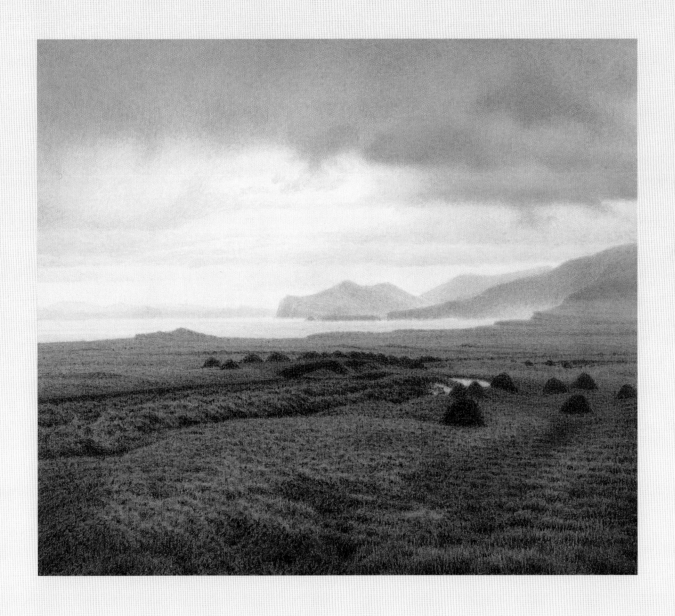

Valentia
Southeast by south 3.
Showers.
11 miles.
995 rising slowly.

Knight's town takes its name from the Knight of Kerry, the title of the Anglo-Norman family of Fitzgerald who once owned Valentia. The port is the most westerly in Europe, the reason for making it, in 1858, the starting point for the first transatlantic telegraph cable which linked Valentia with Newfoundland. Although in operation until 1966 it initially only worked for 27 days before failing, the link taking several years to restore. The cable enabled the small nearby mainland town of Cahirciveen to be in direct contact with New York – but, paradoxically, not with Dublin.

After crossing the bridge from Portmagee the road divides. A right turn takes the main route across the island to Knightstown and to the left a narrow road meanders out invitingly over rising ground to the north-west side of the island. I chose this. After only a few metres I saw to the south the Skelligs, backed by an inky blue/grey shower, one of the most striking island views to be had anywhere in the British Isles. Once over the highest point on the road a very different Valentia greeted me.

The emerald green grazing land gave way to low lying brown moorland stretching to the water's edge on the west shore, with nothing but the Atlantic Ocean between me and St. John's, Newfoundland.

Leaving the road I followed a rough track which led out across the boggy ground to a spot where recently cut peat had been stacked. In the distance to the north, I could see that the Atlantic side of the island had been eroded away by the relentless pounding of the sea, leaving tall vertical cliffs; a dramatic demonstration of wave power. Beyond was a distant view of the Dingle peninsula. As I studied the scene, considering a painting, the sky suddenly darkened and I was overtaken by the shower seen earlier beyond the Skelligs.

This shower was moving up from the south, but, as we all know, most of this type of weather comes from the south-west. This, however, has not always been common knowledge. In 1868 the first head of the Met. Office, Vice-Admiral Robert FitzRoy established a network of 15 or so observatories around the British Isles for reporting on the weather. One of these was on Valentia. The number of observatories was later reduced to seven. Valentia, because of its south-westerly location, was the most important of those kept.

By then it had been established that most stormy weather approaches from that direction and the first warnings always came from Valentia.

Anyone looking for the Valentia observatory on the island today will be wasting their time. Although some buildings remain, transmitting weather information direct to shipping by radio telephony and wireless telegraphy, the observatory moved in 1892 to a turreted Victorian villa on the Valentia side of Cahirciveen. The villa must have been a fabulous house when it was first built, with a wonderful view to the south-west down the sound between Valentia and Doulos Head peninsula. It has a garden leading down to the

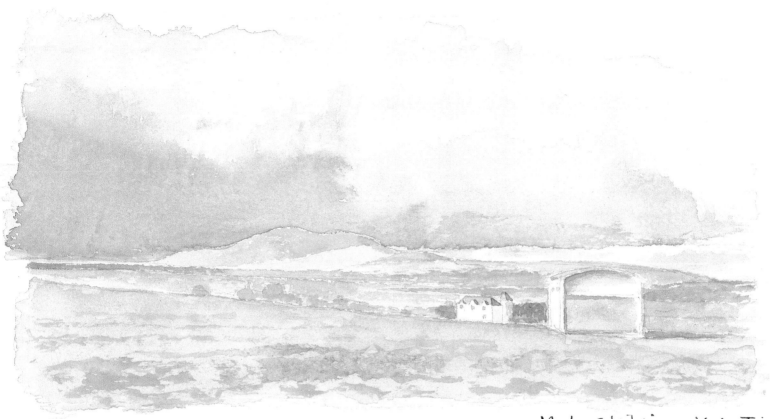

Met. Station, Valentia

water's edge. The site has been developed over the years, most notably by the addition of a pleasantly wacky 1950s communications building and a small hanger containing weather balloons.

I had been fortunate to arrange a meeting with one of the meteorologists on site, Con Curran who explained some of the observatory's history and the work now carried out there.

The hydrogen filled balloons are released three times a day. Each is fitted with a transmitter which sends back readings of temperature, pressure, humidity, wind speed and direction as the balloon climbs through the atmosphere to a height of 15 to 18 km. Balloons may travel as far as Wales or just 3 km, depending on the strength of the wind. Every Friday at midday an additional balloon is released which is fitted with equipment specifically designed for monitoring the ozone layer.

These balloons are valuable items and travel with a 'please return me to Valentia' label, together with a pre-paid envelope and the promise of a IR£25 reward for the lucky finder.

RONALDSWAY

Sometime during the Second World War on a low lying coastal platform overlooking Derby Haven, a natural harbour in the south-east corner of the Isle of Man, an airfield was being extended.

Excavations had revealed evidence of a Neolithic settlement. As there are a number of significant Neolithic monuments on the island this was not that unusual. This one was different, however: A rectangular, mostly timber dwelling containing tools, pottery and the remains of domesticated animals was discovered.

The pottery included straight sided food storage jars and some of the tools were axe heads, made of a volcanic rock found in a particular area of the English Lake District. Also found were some small, oval, slate plaques with a chevron and lozenge design – similar to some discovered in the Iberian Peninsula – suggesting

that the Neolithic peoples moved around the coasts of western Europe.

This was the first evidence of Ronaldsway culture. There is no village of Ronaldsway, but there is a Ronaldsway Farm at the eastern end of the airfield.

The weather forecast for my first full day on Man was not very promising, but the next day was due to be better. I had decided that my time would be best employed reconnoitring a few likely locations for painting that I had identified from studying the Ordnance Survey map. I also had a flexible appointment at the airport and made this my first port of call, to meet the staff of the smallest Met. Office in the world.

After obtaining my security pass I was taken to a suite of offices in the control tower, below the air traffic control room. Four men were on duty out of

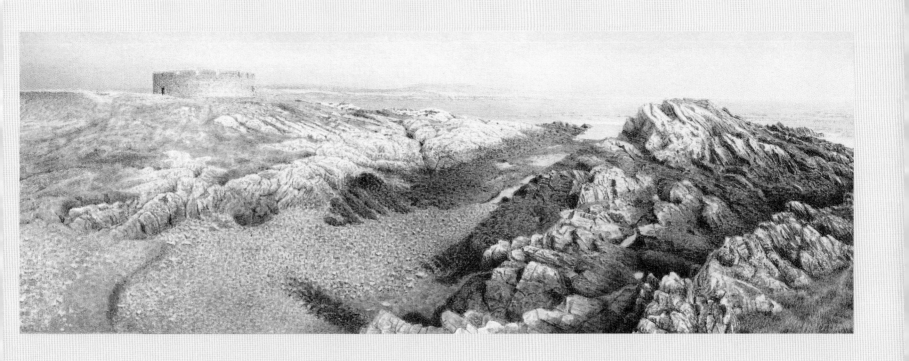

Ronaldsway
South by west 3.
4 miles.
1019 now falling.

a total work force of nine. Hong Kong Met. Office is considered to be a small operation and they have a staff of forty. This was Bracknell in miniature. Originally the Manx Met. Office was an outpost of Bracknell, now it is controlled by the Isle of Man parliament, the Tynwald, so the Met. Officers are Isle of Man civil servants.

Weather data is sent to Bracknell every half an hour except at night when the airport is closed to flights and these reports are reduced to hourly ones. In return Bracknell supplies them with data they do not have the resources to produce themselves; five day projections, that sort of thing. About half their work is for the benefit of the aircraft, and so some of the data from their monitoring equipment goes straight upstairs to air traffic control.

Of particular importance on the day of my visit was visibility which was poor when I arrived with the cloud base very low. Cloud base is measured by an instrument that sends laser beams vertically and measures the time they take to reflect back off the clouds. This time is then converted into cloud height. During my visit it became quite foggy. We heard an aircraft from Jersey make two low passes without the crew being able to see any landing lights, so it was eventually diverted to Belfast.

Cesna landing at Ronaldsway

A weather service for Manx Radio is also provided and in fact it was one of these forecasters I heard that morning on the local news bulletin which included a Shipping Forecast for north Irish Sea.

I could not come all this way without asking about smoke. Ronaldsway is the only coastal station on the Shipping Forecast to report smoke. Why? They receive several letters each year enquiring about their unique reporting of smoke, in answer to which they have now produced a standard letter.

I was told that because they are meteorologists – whereas most other observers will be coastguards, mariners etc. – so they understand better the conditions they are observing. Smoke is usually reported when the wind is blowing from the east or south-east. This means the air is coming from industrial Lancashire. Given the right conditions, for instance when there is temperature inversion, a mist-like smoke bank can be seen at low level. When there is a prolonged period of high pressure over the North Sea, more smoke can be pulled across from as far away as the industrial Ruhr region in Germany.

With visibility too poor to consider painting I first had a look around nearby Castletown, without doubt the jewel of the island and a former capital. The Nautical Museum there is small but excellent. The rest of the day I spent looking at potential painting spots in anticipation of the forecasted improvement.

The next day I returned to a bright but misty Derby Haven to commence work. The Haven is a low lying curving bay facing north-east, with Ronaldsway airfield being on the western side of the bay. On the eastern side, known as St. Michael's Island, stands the circular Derby Fort. Built around 1540 as part of Henry VIII's system of coastal defences, it was refurbished by the seventh Earl of Derby during the Civil War. Around this time it also functioned as a lighthouse, a light being shown from a little turret on the rampart walkway when the herring fleet was at sea.

From the water's edge the fort was slightly hidden by a grassy ridge and did not dominate the scene. Ronaldsway was still visible across the Haven. The sunlight on the swirling mist meant that the rocky edge of the airfield was occasionally invisible and at best bright but indistinct.

MALIN HEAD

'...and finally Malin Head. South-east 5. Twenty five miles. 1013 rising slowly. And that concludes the shipping forecast and weather reports from coastal stations.'

And this concluded my travels. I had reached the end of the road, and Malin Head in Ireland looked the sort of place where the road ran out several kilometres back. Even the trees have not bothered to venture out this far to see if it is worth colonising.

I had been hoping for a dramatic conclusion, something so stunning that all 26,000 km of my journeying would be worth it just for this one view. However my first impression was that the land just peters out. It felt like I had simply run out of ground on which to stand. Behind me to the south was a finger of land jutting out from the Inishowen Peninsula; a pocket size wilderness, a

few square kilometres of rocky moorland so stern and hard-hearted it could shrug off anything the weather cared to insult it with. To the north was nothing but the North Atlantic and the Arctic.

Surely there was a twinkle in its eye somewhere, just for me, just on this one special occasion?

I had arrived at the small village of Culdaff in darkness the night before, welcomed with 'You should have been here last night. We saw the Northern Lights.' My journey had taken me through grim border fortifications, firstly at Strabane and again between Derry and Muff where the Inishowen Peninsula begins. Culdaff is sited next to the sea on that part of the peninsula where it is not that easy to determine where it ends and where Malin Head, in essence a further peninsula, begins. Just down the

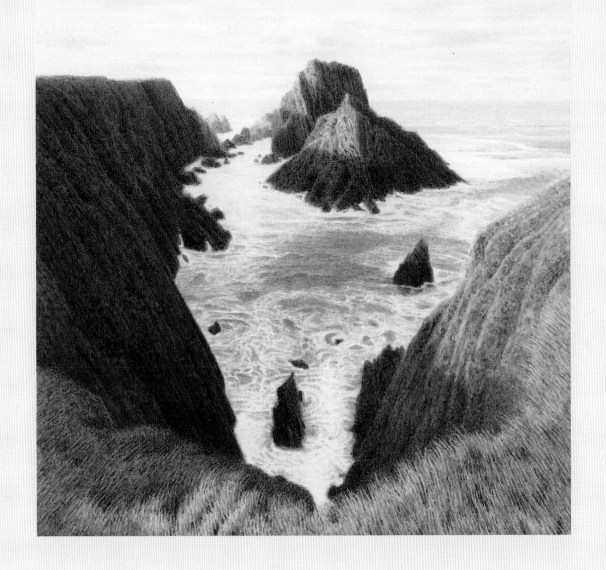

Malin Head
Southeast 5.
25 miles.
1013 rising slowly.

Lloyd's tower in distance

road to the west, on the other shore is the village of Malin itself.

I had arrived tired and in need of sustenance and was surprised to find that the few dozen houses that are Culdaff, at eight o'clock on a Sunday evening at the end of November, had three bars and a cafe open. At McGory's, on enquiring why a pub needs a boiling kettle behind the bar I was introduced to the delights of hot whiskey – one part whiskey, three parts hot water, a little sugar and a slice of lemon with five cloves stuck in it; wonderful.

The next morning I set out for Malin Head. The village of Malin, attractively laid out round a triangular green, is a plantation settlement. In the seventeenth century Elizabeth I and James I conducted a policy of colonisation known as plantation, where land was taken from the local Irish population and given to Protestant settlers from Scotland and England.

It struck me as a curious irony that this action which had produced such a pretty and peaceful village had also sown the seeds of division so starkly manifested in the sinister barriers

constructed just a few kilometres down the road.

Beyond Malin through massive sand dunes the road meanders out for 13 km across hilly terrain, through the tiny community of Ballyhillion and finally past the Met Éireann meteorological station. On first encounter the scattering of rocky outcrops from the otherwise wet peaty landscape created a confusing array of hills, headlands, spurs, bays and islets. Somewhere here was the most northerly point of Ireland but my usually reliable sense of direction had momentarily let me down.

At the highest point stands a tall stone tower, built in 1805 and used for many years by Lloyd's as a signalling station. In the nineteenth century, when crossing the Atlantic was less predictable than it is now, an observer would note the ships returning to British ports, and by telegraph inform Lloyd's of their safe return. From here I was able to work out which way was north and therefore where Ireland came to an end.

Surveying this bleak parcel of land and its watery surrounds from the shelter of the lookout tower, it was easy to see why Paddy Delaney and his colleagues at the met. station say the readings from here are more representative of a marine location than a land based one. The aspect is very open and, not surprisingly, it is the windiest spot in Ireland – more often than not recording the strongest gusts of each month.

The view from here was not the most inspiring and I decided to cross to the west side of the headland, hoping that a more paintable scene would present itself. I arrived eventually at the water's edge, with a view to the south-west across to Lough Swilly and the north Donegal coast. Maybe this was the view, but, as pleasant as it was, I felt that as this was the end of my Shipping Forecast journey, I ought to be looking out to the sea beyond, not back at another stretch of coastline. With this thought I turned round to look at the ground I had just crossed and noticed an aspect of it I had not so far been aware of; a raised beach.

In the past the sea level here had been many metres higher than at present, leaving behind a shingle beach and a cliff face now surrounded by a sea of peat. Studying the old cliff I noticed a substantial piece of rock about 10 m high projecting beyond the ridge that was the old cliff top.

Suddenly I was gripped by a tingle of excitement. Making my way across to the cliff with my heart pounding I was thinking to myself 'this is it, this is going to be the drama I am hoping for. There is going to be a stack and it's going to be huge'. I scrambled up the last incline to a point where a large wedge of land had been eroded from the cliff. Was there a stack? Yes, two of them.

Malin Head – I took it all back; it provided a beautiful ending.

BUTT OF LEWIS LIGHTHOUSE & ST ABB'S HEAD

The task of illustrating the Shipping Forecast has been a long one and since beginning my journeying some familiar names have dropped out of the daily weather log. Two of these are particularly resonant locations and as I visited and painted them, I include them here as illustrations and examples of the changes which occasionally take place.

Certainly those who have lived with the Shipping Forecast for more than a couple of years will find the names of Butt of Lewis Lighthouse and St Abb's Head familiar. Many, I know, still think that they continue to be used. Such is the way of these things; they become so familiar that they enter the consciousness.

The conversion of the lighthouse to automatic operation in 1993 brought an end to St Abb's Head as a Coastal Station, being replaced by readings

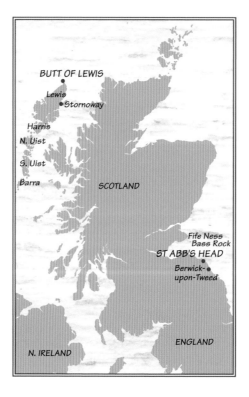

from the coastguard station at Fife Ness, 36 km to the north. St Abb's Head had superseded Bell Rock, a lighthouse on the Inchcape Reef, a submerged sandstone plateau 19 km off Arbroath.

The Butt of Lewis Lighthouse ceased to be used in April 1995, just two days after I finished my painting. Lewis, one of the Western Isles in the Hebrides, is the major part of a long chain of islands. They stretch northwards from Barra Head in the south through Barra, South Uist, Benbecula, North Uist, Harris with the Butt of Lewis at the northernmost tip. All have a rugged grandeur and their own individual character, both geographical and cultural, but nowhere out there is as barren as the northern half of Lewis.

Driving out from Stornoway the land for the most part is on the flat side of undulating.

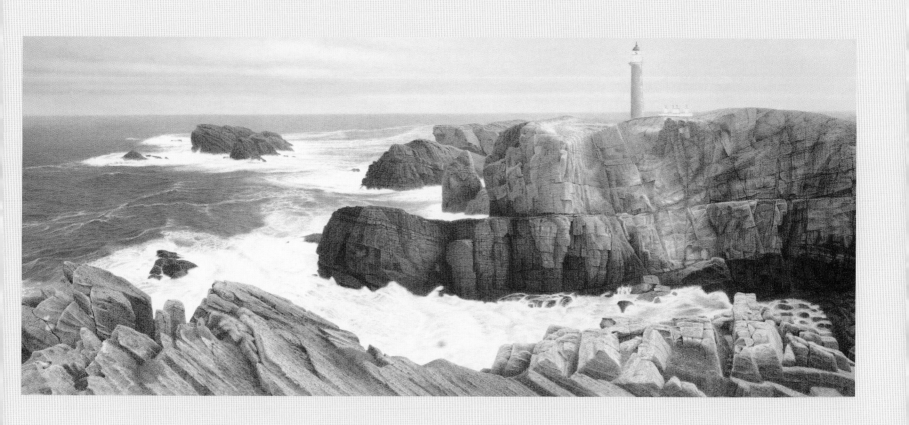

Butt of Lewis Lighthouse
Southwest by west 5.
16 miles.
1013 rising slowly.

Communities are few and scattered with little sign of activity – and how could there be? The land looks unable to support the kind of agriculture most of us will be familiar with. What isn't bare rock or water is peat bog. I saw very few people, and most of those were women cutting peat, the one abundant natural resource, for winter fuel. A striking feature of the landscape is the great stacks of peat beside each house.

At the Butt of Lewis the peat gives way to grass. The land rises gently and invitingly to the promontory, concealing from the landward side the spectacular scene beyond. The sea has cut great jagged wedges out of the dark cliffs. The land breaks away in a series of craggy outcrops as if a few more square miles have been torn away at this point. A rich, dark blue sea becomes a foaming white mass near the cliff base and occasionally engulfs the smaller rocky outcrops.

At the cliff edge the updraft feels strong enough to lean against. It is not difficult to believe that on average a gale is recorded here every six days, blowing up to 100 mph two or three times a year.

From a distance the lighthouse looks a delicate shade of pink; most unusual. The approach is through a courtyard formed by the perimeter wall and the houses where the lighthouse keepers and their families lived. Close up it is clear that the tower is of unpainted brick.

Built between 1859 and 1862 the engineers were the brothers David and Thomas Stevenson, from a three generation dynasty which built more than eighty lights for the Northern Lighthouse Board. Thomas was the father of the writer Robert Louis Stevenson (christened Robert *Lewis*, it is tempting to consider that dad's work here led to the name being given) who as a child would visit these remote places with his father, fostering his love of the sea and a special love of the Hebrides.

St Abb's Head lighthouse was also built by these Stevensons in 1862.

Between Cockburnspath and Berwick upon Tweed the otherwise low lying coastline of small headlands and sandy bays from Edinburgh to Newcastle upon Tyne rises to a magnificent igneous fortress at St Abb's Head. There are few safe havens along the rocky shore, one such is near Northfield where a harbour was built to provide shelter for the herring fleet. A small village grew overlooking the harbour and its name became Coldingham Shore which was later changed to St Abb's, after the seventh century Northumbrian princess St. Aebbe who had founded a monastery on the headland to the north.

The herring fleet has gone but tradition lives on in the Herring Queen Festival held in July, when the new Herring Queen is escorted from St Abb's to nearby Eyemouth by decorated fishing vessels.

Eyemouth is the only town on a stretch of coast that has few centres of population. In sea-bird terms however St Abb's Head is a metropolis.

Seventy eight hectares of the headland is a wildlife reserve and part of a larger Site of Special Scientific Interest. Since 1980 it has belonged to

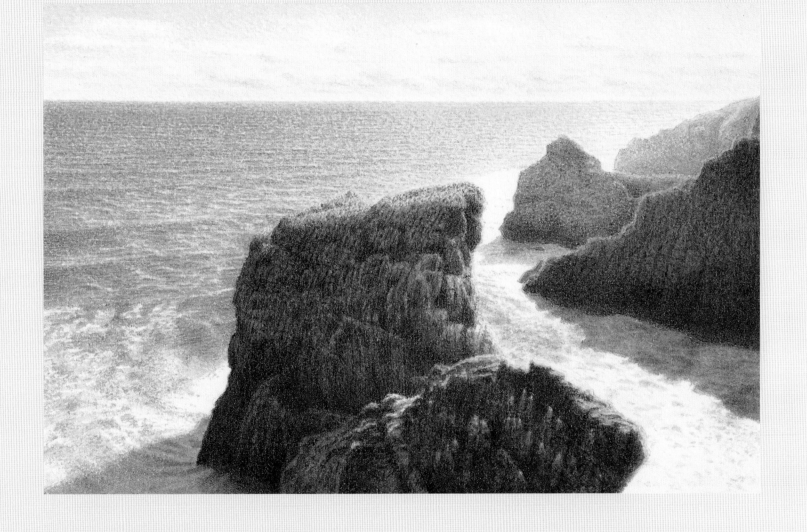

St Abb's Head
Northwest by west 5.
16 miles.
996 falling slowly.

the National Trust for Scotland, which manages it jointly with Scottish Wildlife Trust and Scottish Natural Heritage through a warden who lives on site. An unusual mix of Atlantic and Arctic marine life occurs in the waters offshore, due to an eddy of the North Atlantic Drift that extends down the north-east coast. Scotland's first voluntary marine nature reserve has been established to protect this unique marine habitat.

I visited St Abb's Head on a cold but sunny May morning, the day after a force 8 gale had torn along the coast. From a junction in Northfield hamlet a narrow road leaves the St Abb's road to a car park, from where a lane passes through a field gate next to a group of farm cottages.

Climbing across open fields of grazing sheep, the landward side of St Abb's Head, a long rounded grassy ridge that stands clear of the cliff line immediately to the north and south, comes into view. For nearly a kilometre the lane runs north-west parallel with the ridge, with a narrow loch in a small glacial valley between them. Beyond the loch the lane turns and crosses the valley at a point called Pettico Wick, where there is a magnificent view along the folded and faulted cliffs to the north. Here it is possible to scramble over rocks to the shore.

A small jetty is all that remains of a salmon fishing station where supplies for the lighthouse were also landed. From Pettico Wick the lane climbs steeply to join the ridge of the headland, passing over to the seaward side through a natural break. Here the lane levels out across an undulating grassy area, then disappears through a gateway into the precincts of the St Abb's lighthouse which is now a private house.

As lighthouses go this one is unusual. The cliffs are 90 m high so the light does not need to be elevated in a tower. To avoid being obscured by low cloud or fog, the lantern is built on a ledge below the cliff top. The keepers reached it down a flight of steps.

Out on the cliff top away from any shelter I was struck by a wall of sound. The roaring of the wind and sea was eclipsed by the calls of thousands of sea birds wheeling around the cliffs. Many thousands more clung to the ledges of the dark cliff faces which were streaked with the guano of generations.

The sea has cut several deep gorges into the headland. Dark chasms with sheer walls filled with the spray from a foaming sea thundering against the rocks far below.

The most distinctive sound came from the kittiwakes, like the howling of hundreds of cats. This cacophony was joined by fulmar, herring gulls, guillemots, razorbills and shag. The cliffs are also home to about 20 breeding pairs of puffins. Up to 50,000 sea birds can be here at the height of the breeding season and the natural drama of the cliffs creates the perfect nesting environment, safe from predators.

Out to sea a mass of white horses were being whipped up by a strong wind, less violent than the

previous day – a mere force 5, but feeling much stronger on the exposed cliff top. I wondered about my safety. It was clear that the best views were from as close to the cliff edge as I could get, but I felt a little unsteady in the gusting wind.

On a headland to the north of one of the gorges I found two large rocky outcrops more than 2 m high that were separated by a gap just wide enough to squeeze through. Looking south across the gorge the cliffs were seen through a haze of spray illuminated by bright sunshine. A tall slim stack stood clear of the cliff face on the north side of the gorge.

I shuffled gingerly through the gap between the rocks until I had one foot right on the cliff edge. I told myself 'it's okay, you're quite safe here. This rock is about as hard as any can be, it isn't going to give way from under you'. Wedging myself firmly in place and with heart pounding I leaned forward and peered down over the edge into the gully below. It was just like being out there with the gulls.

"And that ends The Shipping Forecast, the next will be at . . ."

GLOSSARY

For many landlocked listeners, the curious juxtaposition of words and numbers which follows each evocative name is the Shipping Forecast's charm. This is due as much to what has been left out as to the information included. A sea area forecast, for example, that would be broadcast as:

'Westerly backing southwesterly 3 or 4 increasing 6 later. Showers. Good.'

should read something like this:

'The wind will at first come from a westerly direction, but later it will be coming from a south-westerly direction. It will be of a force 3 or 4 strength on the Beaufort scale which is likely to increase to 6 later. The weather will be showers, with visibility of more than five nautical miles.'

For brevity the words wind, force, weather and visibility are omitted. Read out in full, the forecast would then live up to some people's claim that it is a good cure for insomnia - and a ship sailing through Faeroes when the reading started could be in Viking by the time it had finished.

Now that the missing words have been included the thing begins to make sense. The following is an explanation of each element that makes up the forecast, showing the precise limits of words such as 'poor', 'moderate', and 'falling more slowly'.

A **sea area forecast** consists of the following:

Wind direction – which may be followed by an indication of any expected change in the direction over the period covered by the 24 hour forecast and described as:
Veering: Changing in a clockwise direction, e.g. from a westerly to a north-westerly.
Backing: Changing in an anticlockwise direction, e.g. from a westerly to a south-westerly.
Becoming cyclonic: Indicating a considerable change in wind direction across the path of a depression within the sea area.
Wind speed – using the Beaufort Scale.
Expected weather – a brief description of the type of precipitation; for example, showers, occasional drizzle or rain later. If conditions are expected to be dry the forecast will state 'fair'.
Visibility – which is defined using a curious mixture of metres and nautical miles:
Fog: less than 1000 m.
Poor: between 1000 m and two nautical miles.
Moderate: between two and five nautical miles.
Good: more than five nautical miles.
Superstructure Icing – is occasionally forecast whenever air temperatures are expected to be below 0°C and the sea surface temperatures are equal to or below 7°C. The icing will be described as 'light', 'moderate' or 'severe'.

After the forecast for the sea areas comes the **Weather Reports from Coastal Stations**. This will be a snapshot of the weather at a particular moment from

each of the 13 weather stations around the coasts. This, too, has the defining words of wind, force, weather, visibility, nautical, pressure and hectopascals (formerly known as millibars) omitted. A weather report from a coastal station would be broadcast as:

'South-southeast 4, intermittent slight rain, one and a half miles, 990 falling quickly.'

Adding the relevant words would turn it into:

'The wind is coming from the south-south-east. It is of a force 4 on the Beaufort scale. The weather is of intermittent slight rain with visibility of one and a half nautical miles. The pressure is 990 hectopascals falling at between 3·6 and 6·0 hectopascals over the last three hours.'

The report, then, is made up of:

Wind direction – which is sometimes described as one direction by another, e.g. 'south-west by west'. In this case the wind is not spot-on south-west but slightly to the west of it, yet not far enough to call it west-south-west.

Wind speed – using the Beaufort Scale.

Present weather – including 'past hour', a description of precipitation, if any, even if it is only 'within sight'.

Air pressure – in hectopascals (hPa), formerly referred to as millibars.

Pressure tendency – that is, whether it is rising or falling and if so the rate, measured as the amount of change over the preceding three hours and described as:

Rising (or falling) slowly: a change between 0.1 and 1.5 hPa.

Rising (or falling): a change between 1.6 and 3.5 hPa.

Rising (or falling) quickly: a change between 3.6 and 6.0 hPa.

Rising (or falling) very rapidly: a change of more than 6.0 hPa.

Now rising (or falling): meaning that it has been falling (rising) or steady but at the time of observation was definitely rising (falling).

For those who must know everything, and I imagine if you are that obsessive you would already have written to the Met. Office for details, the following will come as a great comfort.

In the General Synopsis the movement of pressure systems is described as:

Slowly: Moving at less than 15 knots.

Steadily: Moving at 15 to 25 knots.

Rather quickly: Moving at 25 to 35 knots.

Rapidly: Moving at 35 to 45 knots.

Very rapidly: Moving at more than 45 knots.

Occasionally a gale warning is issued at times other than at the beginning of the Shipping Forecast. The gales will be described as:

Imminent: meaning that they are expected within six hours of time of issue.

Soon: expected within six to 12 hours.

Later: expected in more than 12 hours.

The Beaufort Scale – In 1806 Captain, later Admiral Francis Beaufort devised his scale of wind so that it could be measured against a well known standard, in the same way that size or weight was measured. He took as his standard a typical full rigged naval man-of-war, and defined the scale in terms of the effect the wind would have on such a vessel. For example, a force 2 would be sufficient to move the vessel in full sail at 5 to 6 knots. At the other end of the scale, in a force 12 no canvas could be shown at all.

Calm is indicated by 0 and after a hurricane force 12 it is only a series of numbers. From 13 the degree of unpleasantness probably isn't worth bothering about. This 0 to 12 scale received international recognition in 1874 and it was modified in 1926.

ROYAL NATIONAL LIFEBOAT INSTITUTION

My admiration for the RNLI and crew members is unlimited. For 175 years it has existed to save lives at sea and currently can claim an average of four lives saved every day. In addition, 14 more people are helped away from risk.

There are 222 stations, an active fleet of 300 and a relief fleet of 130 additional lifeboats. These are used and maintained by nearly four and a half thousand crew members, including nearly 200 women. All are volunteers.

The oldest national lifeboat service in the world, the RNLI provides, on call, the permanent day and night lifeboat service necessary to cover known and predicted search and rescue requirements up to 50 miles out from the coast of the United Kingdom and Republic of Ireland.

Although supported entirely by voluntary contributions, it is a highly professional life-saving service. More than 80 per cent of the RNLI income is dedicated to operational expenditure – building, equipping, manning and operating the lifeboats.

The RNLI is giving the nation very good value for money. The 175th anniversary will, no doubt, demonstrate that lifeboats and the people who run them are needed more than ever. The volunteer spirit has remained constant since 1824 and will continue into the new millennium. An ambitious programme of development and investment in all the latest technology will ensure that the safety of the lifeboat crews and those who they serve is paramount. Long may the RNLI continue!

Distress calls can come at any time of the year, day and night. They can come in all kinds of weather – good, bad and awful – but they are always answered.